The Technique of Kinetic Art

The Technique of
Kinetic Art

John Tovey

B T **Batsford Limited** **London**
VNR **Van Nostrand Reinhold Company**
New York Cincinnati Toronto London Melbourne

Library of Congress Catalog Card Number 72-161979
SBN 442-28577 (USA)

Printed and bound in Denmark by F E Bording Limited Copenhagen
Published in Great Britain by B T Batsford Limited
4 Fitzhardinge Street London W1
and in the United States by
Van Nostrand Reinhold Company
A Division of Litton Educational Publishing Inc
450 West 33rd Street New York NY 10001

Contents

Preface

I fully realise that there is no such thing as a 'technique' of kinetic art, and that techniques are discovered or created in response to the needs of the individual artist when striving to express his ideas. However, there are certain techniques and areas of knowledge that are frequently of value when exploring both real and virtual kinetic effects, and this book has been written in the hope that sudents may be able to spend more time and energy on the creative side of their work and less on re-discovering for themselves already established techniques from widely differing sources. Often when a student realises what knowledge he requires, he is either baffled by the complexity of technical literature or frustrated by the lack of books between the simple, non-technical books and the technical textbooks.

In planning the content and format of this book I have been influenced to some extent by the needs of the Diploma in Art and Design, Fine Art, and Foundation Course students with whom I have been working for the past few years, and I hope that it will provide sufficient information on the various subjects to enable students to pursue in greater depth any topic that particularly interests them.

A knowledge of technique alone will not make an artist, but it may well prevent a potentially good student from giving up in despair when he realises that he is faced with an ever increasing volume of technical knowledge in the development of his ideas.

To the American reader

There are certain small differences between English and American terminology and practice. Most of these will be obvious to the discerning reader but there are two points involving electrical safety which should be emphasised. The colour coding of cables in Great Britain has been altered to conform to accepted international standards and is now as follows:

Line	brown
Neutral	light blue
Earth	green/yellow

The colours were chosen to assist identification by tone in semi-darkness, and to obviate mistakes due to colour blindness. The former colours of *line* red; *neutral* black; *earth* green are no longer used.

The American equivalents are:

Line (power line)	black
Neutral	white
Earth (ground)	green

The mains supply in Great Britain is 240 volts A.C. at 50 Hz and the American supply is 115 volts at 60 Hz. Any British apparatus used must be either modified to operate on the American voltage of 115/120 volts A.C. 60 Hz or preferably run from a mains transformer which steps up the voltage. In a few cases certain components may not be tolerant of the change of frequency. In Chapters 11 and 12 halve the voltage and double the amperage in the arithmetical examples dealing with British mains voltage to alter them to the American standards.

Dr R. G. Costello of the Cooper Union for the Advancement of Science and Art is responsible for compiling the US Bibliography and the list of American suppliers.

Acknowledgment

The author wishes to thank those who have helped in the preparation of this book, and particularly the following: Miss Nancy M. Lamplugh, Regional College of Art, Kingston-upon-Hull, for photographs of her work; Messrs John C. Olley and John W. M. McKain, College of Technology, Kingston-upon-Hull, for verifying the chapters on electronics and for experimental work respectively; Mr James Proctor for work on models and electronic units; Miss Catherine Cullen of C. S. Cullen (Photographers) Ltd, for much of the photographic work, and Mr John Landon for help initially.

Thanks are also due to the Galerie Denise René, Paris, the Trustees of the Tate Gallery, London, the Ferens Art Gallery, and Kingston-upon-Hull Corporation for permission to reproduce photographs of works in their possession or for which the copyright is held, and to the artists Angel Duarte, Julio Le Parc and Victor Vaserely for supplying photographs of their work. The following firms kindly granted permission to utilise material from their publications, Messrs Mullard Ltd, S.T.C. Semiconductors Ltd, Radiospares Ltd, B.P. Chemicals Ltd, *International Lighting Review*, and the Editor of *Practical Electronics*.

JT

Kingston-upon-Hull 1971

Introduction

The primitive eye, single celled, is no more than a detector of light and darkness. The multi-celled eye, such as the fly's eye or the eye of the trilobite fossilized 500 million years ago, is a group of single-celled eyes, and is a movement detector, as different cells can register different intensities of illumination simultaneously, and the shadow of advancing danger cuts off the light to the cells in turn.

In the human eye, instead of each cell having its own lens and receptor, there is one lens only, and the receptors lie in the back of the eye. This means that the receptors can be closer together, and give much finer detail than the multi-celled eye. In addition, the receptors have evolved in two ways, some becoming more efficient in tonal, or light and dark vision, others developing sensitivity to colour (see *chapter 1*). The eye, as well as retaining its primary utilitarian function, has finally allowed man to respond to visual aesthetic experience.

The earliest works of art yet discovered, the cave paintings of Altamira, show that mankind was concerned with depicting animals with the appearance of being in motion. This awareness of movement in primitive man was not solely an artistic interest, it was necessary for his very survival as a hunter.

The preoccupation with movement has never been lost, and although the works of some periods, eg, the frescoes and paintings of the Egyptians and Byzantines, are less concerned with movement, the works of other periods, such as the Italian Renaissance, are full of movement. In the early part of the twentieth century the camera proved to be a disappointment, as the photographs did not capture movement or the sense of movement, but froze it instead. With the development of the camera and of new photographic techniques it is now possible to give the final print a sense of movement equal to that achieved by the artists of the past.

When electricity became a practicable source of power for light, inevitably a 'light organ' appeared as a means of mixing and fading banks of lights projected on to a screen. In this way time became a factor. Hitherto a work had occupied two or three dimensional space, but had not changed. Now the work had to be watched for a definite length of time, until the cycle of change was completed and, as in music, the form of the work had to be retained in the mind until the sequence was complete.

Physical movement can also be used quite easily with small electric motors, and in a kinetic work the light may be static (natural or artificial), and an object on which it falls may be in motion.

The rapid advance of electronic knowledge has brought sensitive control systems which can cause light or moving objects to react to sound, light or movement, controlled or caused by the spectator. This has introduced cybernetics, or the science of control and communication, into kinetic art, and has made possible large scale works in which the environment reacts to the individual instead of vice versa.

At the same time, the increasing knowledge of the workings of the eye and the brain, and nervous system generally, enabled a completely different approach to be evolved. The brain can be deceived into registering movements if the correct stimuli are presented to the eyes, although in fact no actual movement is taking place (see *chapter 2*).

Collateral with this, another type of kinetic work has been developed in which the movement of the spectator past the object either creates a sense of movement in part of the work, though the work itself is entirely static, or by means of mirrors or lenses causes parts of the work to appear to move rapidly in response to the slower, smaller movement of the spectator. In works of these types the physical properties of the eye-brain system and the psychology of perception are exploited.

Kinetic art, therefore, may be divided into two main types, one in which the movement is virtual, and one in which it is actual. The latter area may be subdivided into two groups, the two dimensional and three dimensional.

Actual movement in the three dimensional

group can be produced by a motor or motors, or may be random, caused by air currents. Mechanical movement is essentially repetitive, although the time cycle may be quite long, particularly if the length of the overall cycle is determined by the combination of a number of subsidiary cycles of varying lengths which only very infrequently are in phase together. Cybernetically controlled movement stands between the two sub-groups, as although it is produced by mechanical means, the control of this movement relies for its operation on transducers which respond to changes in the environment (ie, temperature, air pressure, light intensity, wind speed, spectator proximity). Whilst each transducer has predictable and predetermined responses to any given set of parameters, the movements resulting from a number of transducers reacting simultaneously to different sets of parameters will have a random quality because of the almost infinite number of possible combinations of kind and degree obtainable with even a few transducers. Movement may also be initiated actively by the spectator, as he may be invited to operate controls or may have to supply the motive power himself via a handle or lever.

The movement of a mobile in currents of air may be considered as random, because although each individual part can move only within the limits set by its linkage, the juxtaposition of the parts within the whole is determined by chance movements of the surrounding air.

Virtual movement is also of two types, the illusory movement caused by the reactions of the retinal system and apparent movement resulting from actual movement of the spectator. The virtual movement may be perceived as the instability of a surface, which in turn is the result of a rapid twitching of the muscles of the eyeball *(nystagmus)* induced by overloading the visual system. The juxtaposition of intense colours also causes a similar effect and in this instance the colours apparently undergo subtle changes, as the eye twitches.

Movement of the spectator causes apparent movement of the object when there are two interactive elements sufficiently far apart for movement to cause apparent displacement. This is particularly noticable in the moiré fringe effects based on two sets of straight or curved lines, the upper one being either a transparent sheet, or a linear element suspended or constructed in front of a regularly lined surface. Compositions on projecting blades require spectator movement on a larger scale to transform the appearance of the composition. This book is not about kinetic art as such, but the means by which it is produced. It is not intended that it should be read through, but that it should serve as a reference book from which ideas may be taken and employed in individual ways.

Part I deals with vision and perception, the physical and psychological aspects of interpreting the visual stimuli. *Part II* covers light and optics; the way that coloured light and pigment can be used, and the methods by which light is controlled by lenses and mirrors. In *Part III* the control of the light source itself is considered, from three points of view; mechanical control by masks or discs; switches and dimmers controlled manually or by small motors, and electronic control, which covers the control of light by sound, frequency, ambient illumination, etc. *Part IV* is concerned with the basic electrical knowledge, measurement of electrical quantities, circuits, low voltage supplies, rectification and stabilisation.

The appendices include technical information on the construction of various items of equipment, calculations and tables.

The subject is so vast that it is impossible to do more than touch on the many aspects of kinetic art. There are some omissions, and in the electronic section particularly, explanations have had to be almost over-simplified to keep the book within reasonable limits. It is hoped that the book will provide the starting points from which to work, and some of the techniques which may be employed.

Part I

1 Vision and perception

(a) Physical system

Physically the optical system is very similar to a computer. In response to an external stimulus the specialised nerve cells in the eye send a train of electrical impulses along the connecting nerve fibres to the brain, which accepts the information represented by the coded signals, and then acts upon the total information available, ie, that represented by the train of incoming pulses, and the existing information already in the memory-store within the brain. The electrical currents involved, though small by everyday standards, are quite large by electronic standards, being some tens of milliamps at about 100 millivolts. The nerve fibres at rest are negatively charged (−60 to −80 mV), and when transmitting become slightly positive (about 20 to 40 mV). The frequency of the pulses varies with the intensity of the stimulus, and may be up to 1,000 pulses per second. Thus there is a very real similarity between the perceptual system and a computer.

The eye itself is approximately spherical and about the same size as a table tennis ball *(1)*. The front of the eye is transparent, and has a protruding dome, the cornea *(1.i)*. Behind this lies the crystalline lens *(1.ii)*, flatter at the front than at the back. The amount of light falling on the lens is controlled by the size of the aperture, or pupil, *(1.iii)* in the iris *(1.iv)*. The space between the cornea and the lens is filled with a fluid substance, the aqueous humor *(1.v)*. The main cavity within the eye is filled with a jelly, the vitreous humor *(1.vi)*, and at the back of the eye and reaching round to the sides, the retina *(1.vii)*. Immediately opposite the lens, at the back of the eye, is the fovea *(1.viii)*, the most sensitive region of the retina, and on the nasal side of the eye the optic nerve *(1.ix)* leaves the eye, creating an insensitive 'blind spot' where it does so.

The cornea and lens act in the same way as the lens of a camera: they focus the incoming rays of light on to the retina, forming a small inverted image on the back of the eye. The cornea does most of the focussing, as the light passes from the less dense air into the denser medium of the eye. The refractory index of the lens is only slightly higher than that of the aqueous humor, so the lens cannot bend the light very much (see *chapter 4 and 1c*). Its importance lies in accommodation for near and distance vision, the lens becoming thicker for nearer objects.

The retina, on which the image falls, is an extension of the brain which has become sensitive to light. The cells furthest from the brain are the photo-receptors, connected by a layer of brain cells to the optic nerve, and forming a computing layer for processing the information from the receptors. The brain itself therefore receives information already reduced to its essentials by the brain cells in the eye.

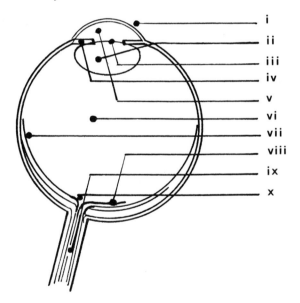

1 *The anatomy of the eye*

i *Cornea*	*vi* *Vitreous humor*
ii *Crystalline lens*	*vii* *Retinal layer*
iii *Pupil*	*viii* *Fovea*
iv *Iris*	*ix* *Optic nerve*
v *Aqueous humor*	*x* *Blind spot*

The nerves from the retina are grouped into a left and a right section from each eye. The nerves from the left side of both eyes go to the left half of the brain, and those from the right side to the right side of the brain, so that the brain compares and processes the signals from the same side of both eyes together.

The retina itself is a mass of microscopic light-sensitive cells or receptors of two kinds, rods and cones. The rods function in light of low intensity and provide only monochromatic vision, whilst the cones function in high intensity illumination (daylight or strong artificial light), and give colour vision. Daylight vision using cones is called photopic vision, and vision in a dim light using rods is called scotopic vision.

Photopic vision is centred on the fovea where the cones are smallest in size and most closely packed together to form the area of the retina which gives the greatest visual detail. The size can be stated in two different ways. The smallest receptors of all, right in the centre, measure only one micron across (one thousandth of a millimetre, see Appendix section A), and in optical terms subtend an angle of about 24″ of arc, ie, the angle represented by lines from the two sides of a capital letter M in this book held 10·8 m (12 yards) away.

According to the most widely held theories there are three types of cones, each type reacting to light of a different wave length (see *chapter 5*), to give colour vision. The cones are less sensitive to low levels of illumination than the rods, and the proportion of cones to rods becomes less as the distance from the fovea increases *(2)*.

The rods represent a more primitive stage in the development of the eye. They are more sensitive to light than the cones, and as the edge of the retina is approached they become no more than detectors of the movement of shadows. At the extreme edge of the retina the stimulation of the receptors does not even produce a visual sensation, but causes a reflex movement of the eye towards the position of the movement.

The whole of this complex system of light sensitive cells, computing cells and nerve fibres at the back of the eye is apparently inside out *(3)*. The receptor cells are on the back of

2 *Rod-cone distribution on the retina*
2 a *Initiation of movement*
2 b *Scotopic vision*
2 c *Fovea (photopic vision)*

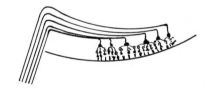

3 *The inversion of the retinal layer of nerves*

the retina, and the light has to pass through the layer of connecting nerve fibres and the computing layer before reaching the rods and cones. This is a result of the development of the eye from the brain before birth *(4)*.

4 *The development of the eye in the foetus*

15

(b) Perception of brightness

The rate of firing of the receptors is controlled by the strength of the stimulus, the stronger the light the higher the rate of firing. The reaction to a stimulus is proportional to the logarithm of the stimulus, and not simply to the size of the stimulus. This means that to produce a light apparently twice as bright as another the intensity of light has to be squared. If the intensities of five lights in a row are controlled so that they appear to increase in brightness in four equal steps the value of the current through each bulb will be found to have been multiplied by a constant factor for each stage *(5)*.

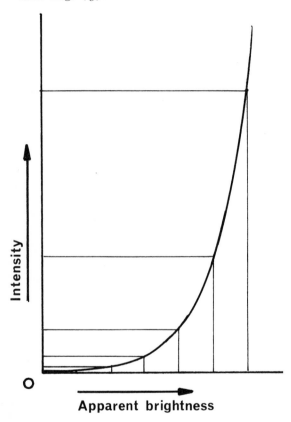

5 *Graph of intensity plotted against brightness*

A corollary of this is that a small increase in brightness at a low general level of illumination will be perceived, but a very much greater increase is needed at higher levels of illumination. In other words, the least discernable difference between an object and its background is a constant fraction of the general level of illumination. An actual increase in brightness which is adequate in moonlight will be barely perceptible in artificial light, and impossible to detect in daylight. Thus the eye which can see quite clearly in moonlight is undamaged by strong sunlight. As it becomes dark-adapted it becomes more sensitive to small stimuli, but loses the power to distinguish fine detail or rapid changes in intensity, because the retina needs stimulating over a greater area and for a longer time before it will react (see Appendix page 132).

This is partly to overcome the effects of residual neural activity on the brain, which may be likened to the 'noise' in a radio, tape-recorder, etc. If the level of illumination is low the signals reaching the brain are very little stronger than the random signals of the 'noise', which are rejected by the brain, and so the spatial and temporal increase in stimulus is demanded by the brain to differentiate between 'noise' and signal.

The degree of contrast between an object and its background also has an effect on perception. An area of constant brightness will appear to be brighter on a dark ground than on a light ground, and vice versa. Only the edges of an area of uniform intensity of illumination are signalled to the brain, the receptors covering the area itself and the field around it remaining silent. This process, called lateral inhibition, is quite simply demonstrated diagrammatically. *(6a)* (A) and (B) are the light sensitive receptors, and a layer of computing cells respectively, and the connecting fibres are shown at (C). One fibre from each cell in (A) connects with a cell in the next layer on either side, this link being an inhibitory link, and a pair of fibres connects with the cell immediately below it forming an excitory link. If all four cells in A are equally stimulated, each cell in B will receive from the cell above it two direct impulses which will be cancelled by the two inhibiting impulses, one each from the cells on either side, and the whole group will remain silent. *(6b)* If cells (i) and (ii) in layer A are now strongly illuminated, and cells (iii) and (iv) less so, A (i) and (ii) will signal a high level and A (iii) and (iv) a low level of light intensity.

Cells B (i) and (iv) therefore will have the two incoming excitatory signals cancelled by the inhibitory signals as before, and will remain silent. B (ii) will receive two stimuli to fire, from A (ii), but only one cancelling stimulus, from A (i), and so will signal the presence of a light-dark boundary, left light and right dark. B (iii) will be actively inhibited from A (ii) and confirm the signal from B (ii). Along similar lines, the visual system effects a considerable economy of neural energy, both in the transmission and the interpretation of signals. The effects which may be attributed to this are discussed on pages 27 to 29.

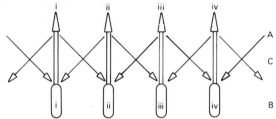

6 a *Operation of the computer layer*

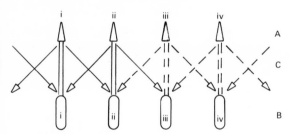

6 b *Edge-detection in the computer layer*

(c) Perception of movement

The eye is primarily a detector of movement, for which it utilises two different systems which work in conjunction, a retinal system and a muscular system. The retinal system depends on the receptors firing sequentially as an image moves across the retina *(7a)*, and the muscular system depends on the movements of the eye within the eye socket, the image remaining relatively stationary on the retina *(7b)*.

As most types of receptors signal only the changing of the intensity of illumination, they will fire only when a shadow edge passes them, the velocity of the object causing the shadow being judged by the interval between the firing

7 a *Sequential firing of receptors (retinal movement system)*

7 b *Eye movement in the socket (muscular movement system)*

of the receptors. There is no need for a background against which to judge the movement, a small light moving in a completely dark room will still give rise to the sensation of movement, with the eyes held stationary within the head. If, under similar conditions, the light is followed with the eyes, thus effectively fixing the image upon the retina, a sensation of movement is still registered. This involves the muscular system of movement recogniton, in which the movement of the eyes relative to the head gives rise to the necessary signals.

When the eyes are moved in the head the complete field of view sweeps across the retina, but this does not give rise to the sensation of movement. The most logical theory to explain this apparent contradiction is that the movement signals given by the retinal system are nullified by the orders given by the brain to the muscular

17

system which originally initiated the movement, with a suitable delay to allow the arrival of the signal from the retinal system to coincide with the arrival of the nullifying signal from the muscular system.

(d) Interpretation of depth

Depth perception, like movement, depends on two different systems, one involving the movement of the eyes in the head, and the other dependant on the difference between the images from the left and right eyes. The observer's previous experience and memory play a considerable part in interpreting the signals from these two systems.

The angle of convergence between the eyes gives the indication of depth derived from the muscles of the eyeball. A distant object *(8a)* will be seen with only a small angle of convergence, while a near object will need a much greater angle *(8b)*. This system becomes ineffective beyond about 100 metres (100 yards), as the visual axes become substantially parallel.

8 b Large angle of convergence (near object)

8 a Small angle of convergence (distant object)

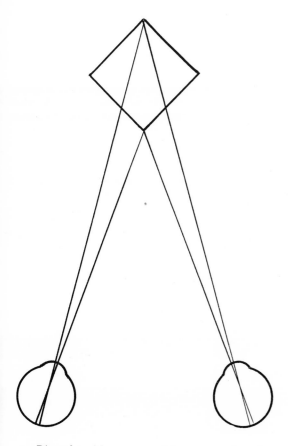

9 *Binocular vision : near and far corners of a cube*

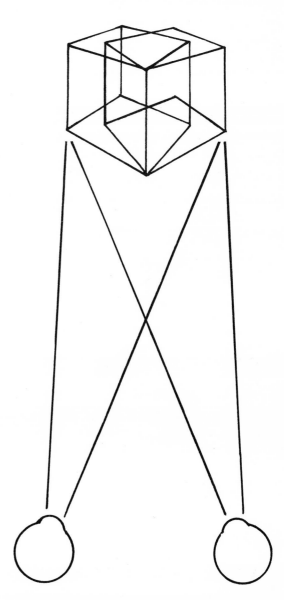

10 *Stereoscopic vision : disparity between images on the left and right retinas*

The disparity between the images from the right and left eyes enables whole objects to be seen three-dimensionally. The convergence angle differs considerably when looking at the near and far corners of a 600 mm (2 foot) cube at 2 m (6 feet) *(9)*, but with the eyes fixed at the near corner the whole cube is seen as a solid because of this disparity *(10)*. This system ceases to be effective beyond the point at which the difference between the images becomes too small to be perceived, at about 8 metres (8 yards).

The observer's interpretation is therefore paramount in perceiving depth beyond any but comparatively short distances, and it is in this field that the eye-brain mechanism may be most easily deceived. Judgement of distance depends on assumptions regarding the shape and size of objects, the direction of light, and lack of clarity of vision. This is discussed in *chapter 2*.

19

(e) Photopic vision

Under conditions of low illumination only the rods are functioning, giving the monochromatic vision known as scotopic. Photopic vision is provided by the cones functioning in high illumination and giving colour vision.

The first theory of colour vision was advanced by Young in the early nineteenth century, and developed by Helmholtz. Despite attempts since to devise others, the Young-Helmholtz theory is still the most satisfactory. It is, simply, that there are three types of cones, each one maximally sensitive to light of a definite frequency or wavelength, those giving rise to the sensations that are called red, green, and blue (see *chapter 5, Colour*). Diagram *11* shows the colour response curves for the three types of receptors. Therefore, any colour that we see must be composed of a mixture of some or all of three primaries in varying proportions, and conversely, all the spectral colours and white light can be made by suitable mixtures of the three primary lights, red, green, and blue (or blue-violet). The area of overall maximum sensitivity is in the yellow and yellow-green regions, but as the general level of illumination falls and the photopic vision is replaced by scotopic vision, the maximum sensitivity shifts towards the shorter wavelengths, into the blue-green area *(12)*.

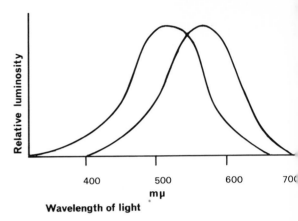

12 Purkinje shift

(f) Interpretation

The information presented to the brain has to be interpreted, and the appropriate response evoked. The incoming data has to be compared with the memory store, similarities with previous experience noted, and a final decision made.

In the case of moving objects a rapid processing of information may be essential for survival, and the brain simplifies the information and organises it where possible to coincide with previous analogous situations to assist the final process of deciding on the action to be initiated. In less vital situations the brain still pursues a similar course, and accepts the most logical, or simplest interpretation in response to any given stimulus. In the absence of any detail which may give the eye a point of focus, the whole system relaxes, and the eyes settle on a nondescript field which is approximately 20 metres (20 yards) away. The effect of this can be demonstrated by evenly illuminating the interior of a smooth hemispherical surface, and observing it in a totally darkened room. As soon as a small point is placed on the surface the eye has a point of focus, and the field immediately becomes defined. In this way an indeterminate field can become a plane of reference.

If an object is now superimposed on the field the brain concentrates on the *figure*, (the

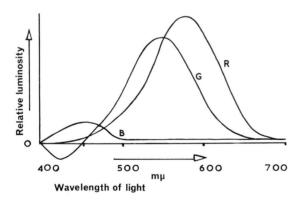

11 Colour response curves

20

object), the field reverts to the *ground*, and signals from it are largely ignored.

The effect can be reproduced by cutting a hole in a sheet of cardboard and viewing it against a plain ground. When attention is concentrated on the cardboard the hole becomes a completely indefinite colour without distance.

This is similar in effect to what happens when driving in bad weather, if attention is diverted to the windscreen-wiper blades instead of the road beyond; the blades become the figure, and the road and traffic the ground. Fortunately the insistence of the movement signals from the eye prevents the ground from being ignored completely for more than a few seconds in this instance.

The figures themselves are organised to make recognition simple. Any slight irregularities in an otherwise regular shape are ignored. In diagram *13* several of the shapes are slightly irregular in differing degrees, but they are perceived initially as regular figures.

13 Irregular shapes

The brain will also make good small deficiencies without being conscious of doing so, particularly under conditions of minimum stimulation. In diagram *14* the gaps in the circles and the squares are closed, and the brain registers them as complete figures if they are viewed briefly. This completion of figures also occurs when small segments of circles are placed on a field; any curved line suggests the circle of which it forms part. Thus any circle tends to give a linear impression, ie a line is drawn on a field, whereas a straight line figure such as a triangle creates the impression of enclosing an area that it is a figure on a field.

14 Incomplete shapes

In diagram *15* the interpolation of the brain between significant edges can be even more forcefully demonstrated if the image of the dot in the centre of the cruciform figure is centred on the blind spot of the eye where the optic nerve leaves the eyeball and there are therefore no receptors. If the figure is viewed with the left eye only from about 400 mm (15 in.), and the eye moved slowly towards the small cross on the right, the centre of the figure will be on the blind spot when the eye is directed at or near the cross. The disconnected corners of the figure are not now being registered directly, but from the data available the brain assumes that the figure is complete, and it is an unbroken figure which is 'seen'.

15 Incomplete cross and blind spot

The brain also selects what is logical when there are different possible interpretations. In diagram *16*, (a) is seen as a single rectangle with a line across it, but (b) is seen as two shapes. (a) *could* be two shapes, but as they would be irregular and less logical than a regular shape this interpretation is discarded.

16 a Single shape with a line across it

16 b Two conjoined shapes

The simple shape in diagram *17a* is still perceived as one shape when two lines are superimposed, as in *17b*. When two lines are drawn as in *17c* there are now three adjacent shapes, but in *17d* there are two shapes, one above the other. In (c) the logical assumption is that two rectangles have been placed on either side of an irregular hexagon, but in (d), by continuing the lines of the centre of the figure, it becomes detached in some degree from the gound.

17 a One single shape
17 b One shape with two superimposed lines

17 c Three shapes with two connecting lines
17 d Two shapes, one superimposed on the other

A similar effect of superimposed planes is created in diagram *18*. This figure is interpreted as the low three dimensional effect of a diamond on a rectangle, and not as a diamond between two re-entrant pentagons.

18 Rectangle and diamond in low relief

The simpler area is usually interpreted as the ground wherever possible. In diagram *19* (a), the circle is usually perceived as the figure on the square ground, and in (b) the square is now the figure within the enclosing circle. As all the shapes are simple, the general effect is of three superimposed shapes. In (c) the small

circle is still perceived as the figure, despite the complexity of the shape of the ground, but in (d), by the addition of the circumscribing circle the small centre is now generally perceived as a hole in the figure through which the ground can be seen.

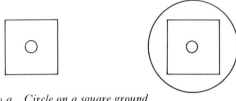

19 a Circle on a square ground
19 b Square figure on a circular ground

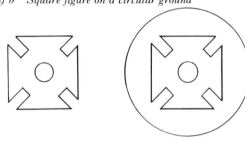

19 c Circular figure on an irregular ground
19 d Irregular figure with a circular hole on a circular ground

A more ambiguous figure is in diagram *20*. Here either of two Maltese crosses can be figure or ground, the straight or circular hatching appearing to be continuous as ground behind whichever is figure. As there are no direct clues as to which is which, the figure and ground appear to change places indiscriminately.

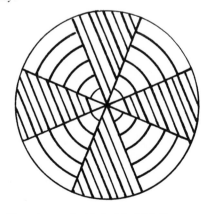

20 Figure/ground with hatched Maltese cross

The crosses in diagram *21* are more definite, and although the orientation of the vertical cross gives it more credence as the figure, it can equally well be interpreted as the ground behind the diagonal cross. Texturing either area has little further effect *(22)*, but adding details which are difficult to reconcile with the ground effectively prevents the ambiguity occuring *(23)*.

Ambiguity is also caused by tilting the frame of reference. In diagram *24* (a) and (b), the local frame of reference (the outer rectangle), is tilted relative to the general frame of reference, (the page of the book,) and confusion arises as to which frame of reference the centre squares should be related. (a) may be perceived as a diamond in a tilted frame, or as a square in a frame and tilted with it, and (b) *vice versa*; whereas in (c) and (d) the local and general frames are the same, and no conflict arises.

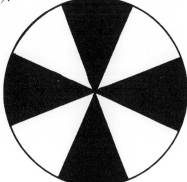

21 Figure/ground in solid Maltese cross

22 Figure/ground with solid and hatched Maltese cross

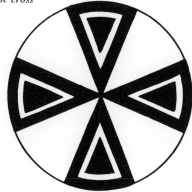

23 Figure/ground with complex figure

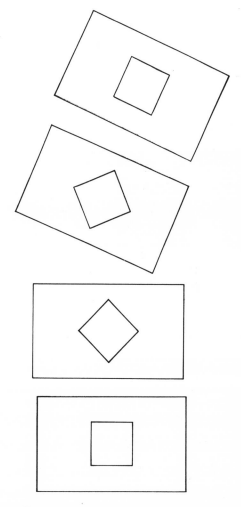

24 a Frame of reference tilted : square figure
24 b Frame of reference tilted : diamond figure
24 c Frame of reference straight : diamond figure
24 d Frame of reference straight : square figure

23

(g) Spatial and temporal induction

Stimulation of part of the retina may affect the response of adjacent areas, or of the same area a short while later.

Spatial induction, or simultaneous contrast, occurs when areas of strong tonal or colour contrast are in juxtaposition. The two classical examples are shown in diagrams 25 and 26. In 25 the grey ring appears to be lighter on the dark ground, and darker on the light ground, and if a pencil or even a piece of fine string is laid along the division in the ground, the ring appears to be two different tones. A similar effect occurs in colour, with a grey ring on a ground of two complementary colours (red and green, or blue and yellow). The grey appears to have a slight but definite admixture of the complementary colour.

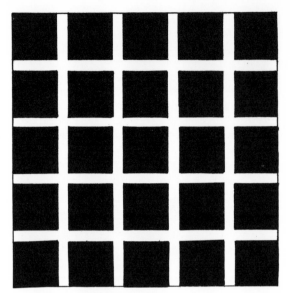

26 *Spatial induction : squares*

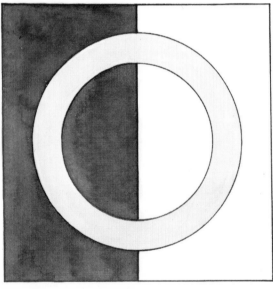

25 *Spatial induction : ring*

The effect in diagram 26 is less definite. Patches of grey appear at the intersections of the white lines, particularly when the eyes are moved across the diagram. In colour, the complementary colour would appear instead of grey. A colour may be induced by a series of black and white lines *(27)*. If the attention is directed to the diagram for several seconds, waved horizontal lines forming feeble but distinct spectra may be visible, though not everyone perceives this effect.

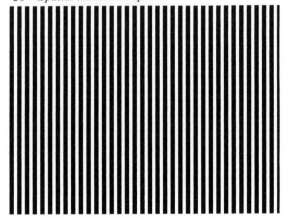

27 *Induction of colour*

Temporal induction is much better known, both in tone and colour. When the gaze is fixed for 30 to 60 seconds on a definite shape, then transferred immediately to a plain ground, the shape is seen in its complementary colour or tone. The black cross in diagram 28 can be placed between the two noughts in this way.

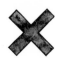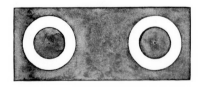

28 *Temporal induction*

24

2 Illusion

Illusions may be caused by both parts of the perceptual system. The retinal system can give misleading signals when overloaded by abnormal stimulation or fatigued by prolonged stimulation, or under certain conditions the brain can misinterpret correctly seen and transmitted data. The latter may be due either to the inability of the brain to decide between two opposing and mutually exclusive interpretations, or to the brain applying the wrong criteria when assessing the information. One example of differing interpretations is the figure/ground effect already referred to *(chapter 1, diagrams 20 to 23)*. Others are discussed later in this chapter (pages 30 to 32).

(a) Two-dimensional illusions

Three common examples of figures wrongly assessed by the brain are the arrow-head, *29*, the converging lines, *30*, and the radiating lines illusions, *31*. The theory advanced by R. L. Gregory in his book *Eye and Brain* is that the illusions are caused by the brain applying size constancy according to the information in the figures which appears to suggest depth, (NB *not* according to the apparent depth, a very different thing).

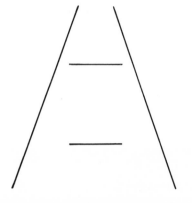

30 Converging lines illusion

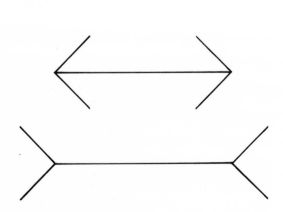

29 Arrow-head illusion

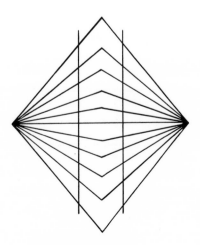

31 Radiating lines illusion

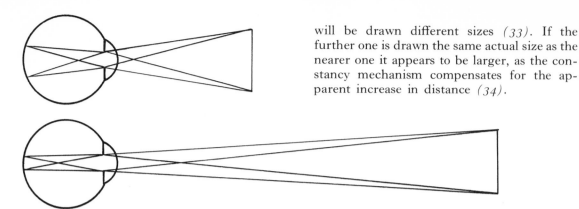

will be drawn different sizes *(33)*. If the further one is drawn the same actual size as the nearer one it appears to be larger, as the constancy mechanism compensates for the apparent increase in distance *(34)*.

32 *Diminishing image size with increasing distance*

Size constancy is the process by which the brain compensates for the steadily diminishing size of the image on the retina as the distance between the eyes and a moving object increases *(32)*. The object continues to look the same size despite the increase in distance.

The converging lines suggest parallel lines in perspective, and two objects of a similar size

The arrow-head illusion works in a similar but less obvious way. The line with the outward pointing arrows suggests the near corner of a solid object, a cube or a building, and the constancy-scaling mechanism reduced the apparent size *(35)*. The line with the inward pointing arrows creates the impression of the far corner of the interior of a similar object, or a room, and is scaled up in size as it is apparently more distant *(36)*.

33 *Converging lines with two objects of different sizes*

35 *Arrow-head effect compared to a building*

34 *Converging lines with two objects of the same size*

36 *Arrow-head effect compared to a room*

26

Both figures appear flat when drawn on paper, as the texture of the paper itself takes precedence over the appearance of depth created by perspective. If the figures are made in wire coated with a luminous paint, and viewed with one eye to remove the stereoscopic depth perception, they both appear as three dimensional as fully three dimensional models made in the same way, as there is now no texture to nullify the perspective effect. Readers are referred to pages 150 to 160 of *Eye and Brain* for full details of these experiments.

Upsetting the visual system by overloading it produces unexpected effects. If the parallel lines of diagram *37* are looked at for a few seconds, wavy horizontal lines appear, which for some subjects are in spectral colours, each line appearing as a small, faint, but nevertheless complete rainbow. This may be due to the continual slight shifting of the eye causing the receptors which signal 'light on' and those which signal 'light off' to send a heavy concentration of signals to the brain. (This is corroborated to some extent by the fact that an intense light flashing on to a white ground at approximately 5 flashes per second can cause the sensation of quite vivid colours.) When the eyes are fixed upon a blank ground after looking at the figure for 15 or 20 seconds the whole field seems to be in movement.

Fall (38) by Bridget Riley shows an example of virtual movement induced by overloading the retinal system, and *Superimposed Chevrons (39)* by François Morellet demonstrates the optical dazzle caused by the repetition of the geometrical elements and creates an illusion of movement perceived in the peripheral fields of vision. The surface of the painting becomes an anonymous, homogenous and unstable structure.

37 Parallel lines (overloading the visual system)

38 'Fall' by Bridget Riley. Reproduced by courtesy of the Trustees of the Tate Gallery, London

39 'Superimposed Chevrons' by François Morellet.
Reproduced by courtesy of Galerie Denise René, Paris

(b) Three-dimensional illusions

These depend on the ambiguity of the figures themselves. The stimulus and the imput to the brain remain unchanged, but the brain is presented with the problem of deciding which of two incompatible but equally valid states to accept. As there is no single correct interpretation, both possibilities are accepted in turn.

The simplest of these ambiguous figures is the skeleton of a cube (40), which may be either to the left of the spectator and below his eye-level, or to his right and above it; and it changes instantaneously and quite haphazardly from one to the other. The back and front faces change places without any apparent change in size, though if a flat luminous wire figure is made, the back face always appears to be larger, as size constancy operates.

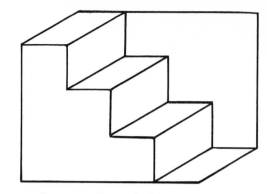

41 a Steps ascending to the left

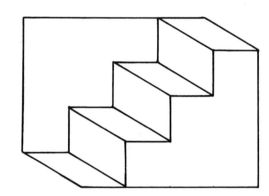

41 b Steps ascending to the right

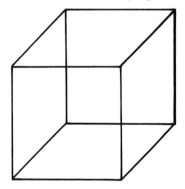

40 Skeleton cube

A similar figure in reversible perspective is the flight of steps, which again alternates between the two positions (41 a, b).

The row of cubes which change in direction (42), or the groups which change in number (43), create the impression of a high-relief surface which slopes towards or away from the observer. The plain statement of perspective as in depicted diagram 42 is assisted by tone in 43, but although it gives added realism to the cubes it introduces another factor, a change in the direction of the lighting (see *chapter 3, section c*).

Another type of ambiguous figure is completely static, as of the two possible interpretations one is much more probable than the

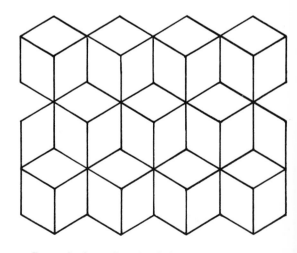

42 Rows of cubes—directional change

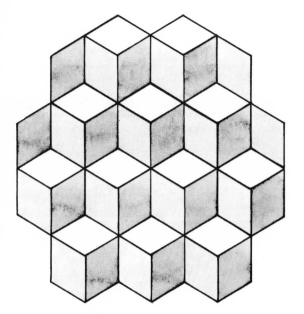

43 Group of cubes—directional change in number

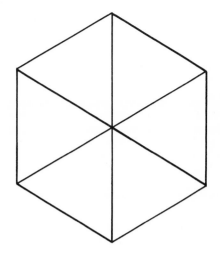

44 b Two dimensional pattern or skeleton cube

other. In diagram *44a* the figure is more prob-
able as a cube, and is seen as such, but in diagram
44b the simpler two dimensional pattern is
chosen in preference to the less obvious cube,
though with a conscious effort this can be seen.
The three interpenetrating planes of *45a* are
reduced in the same way to the two dimensional
pattern of *45b*.

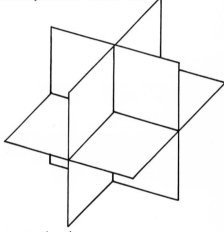

45 a Three interpenetrating planes

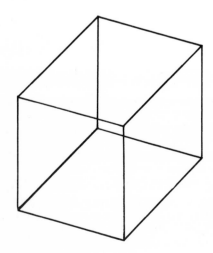

44 a Skeleton cube

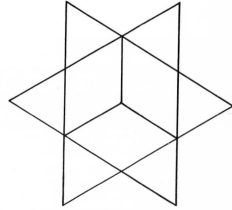

*45 b Two dimensional pattern or three interpene-
trating planes*

A more subtle variation is shown in diagram *46 a, b.* In (a) the figure is a pattern based on concentric hexagons. If a circle is substituted for the outmost hexagon (b), the small center hexagon immediately becomes a three dimensional cube in preference to a flat pattern, as the brain now interprets the centre of the figure apart from the surrounding circle.

A figure which is equally probable in its two dimensional or three dimensional forms is given in diagram *47.* In its two dimensional state it is a hexagonal tessellation constructed of 12 rhombi, but in its three dimensional state it is three cubes either above or below the eye-level (see *chapter 3*). A three-dimensional solid which is itself ambiguous is shown from three

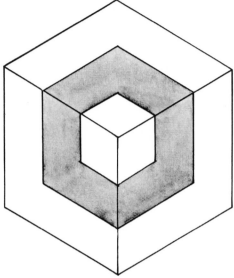

46 a Pattern of concentric hexagons

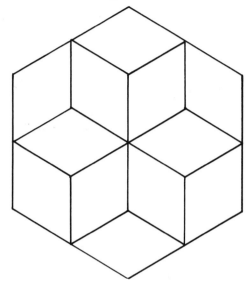

47 Hexagonal tesselation or three cubes

positions in diagram *48* a, b, c; a and b give two totally different but equally misleading impressions of the solid, which is a pair of

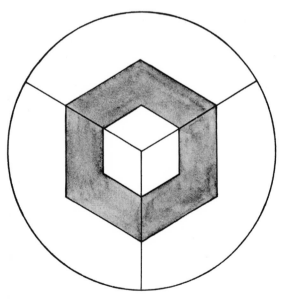

46 b Cube in a circle

48 a Interpenetrating cubes, rosette

interpenetrating cubes. Diagram c shows the solid in a position in which its shape can be correctly interpreted, standing on a second cube which has been constructed with the convex projections replaced by concave indentations.

Virtual movement is created either by optical dazzle sometimes assisted by spatial indiction, or by the creation of space which continually re-forms beyond the surface of the painting, as shown in figures *49, 50* and *51*.

Another type of ambiguity is illustrated in diagrams *48 d(i)* and *d(ii)*. Here the convention of perspective is misused to create apparent solids which have the appearance of being real, but are actually impossible. If any corner of *d(i)* or any side *d(ii)* is covered, the remainder of the figure is possible. The impossibility lies in the continuity of the figures (see *Grafiek en Tekeningen* by M. C. Escher for compositions based on these and other perspective impossibilities).

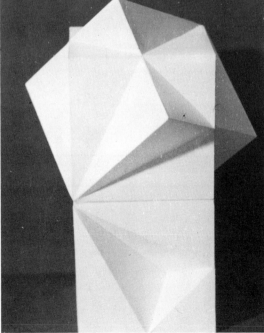

48 b Interpenetrating cubes, indented conical shapes

48 c Interpenetrating cube, standing on a cube with negative penetration

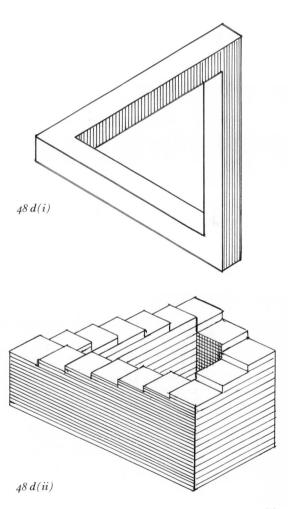

48 d(i)

48 d(ii)

34

50 *'Méandre C' by Victor Vasarely. Reproduced by*
courtesy of Galerie Denise René, Paris

49 *'Tilla' by Victor Vasarely. Reproduced by courtesy*
of Galerie Denise René, Paris

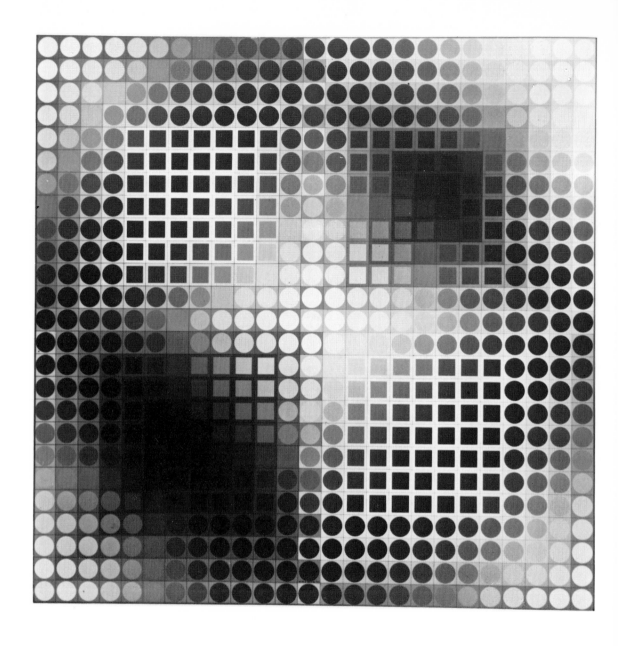

51 *'Sendé' by Victor Vasarely. Reproduced by courtesy of the artist*

36

3 Illusory movement

A sensation of the movement of an object can be caused by the spectator's own movement past the object, the slight alteration of the viewpoint causing a much greater change in the appearance of the object. Changing the lighting can also cause an object to appear to move or to change its shape, both in white and coloured light. Sequential switching of several small lamps placed round a faceted solid can cause the solid to appear to rotate, and alternating back and front illumination can cause a solid shape to appear to advance and recede.

(a) Moiré effects

Moiré effects arise when two repetitive configurations of similar units, of which one at least must be transparent, are superimposed.

The units may be dots, lines, circles in drawn designs or objects such as railings, trees, open weave fabric, etc.

The moiré effect which is seen most often is the 'beat' observed when passing along two parallel sets of similar railings. When two rails, one from each set, are in a direct line with the observer a lighter patch is visible, *(52)*, (B1, A1, O1 shown in plan view). As the observer moves from O1 to O2, A2 appears in line with B3. A smaller movement of the observer has resulted in a larger apparent movement of the beat, and as the observer progresses along the line to O6, the beat moves over a greater distance to A6-B11. Thus if a beat is followed with the eye it apparently moves more quickly than the observer, the moiré effect resulting in

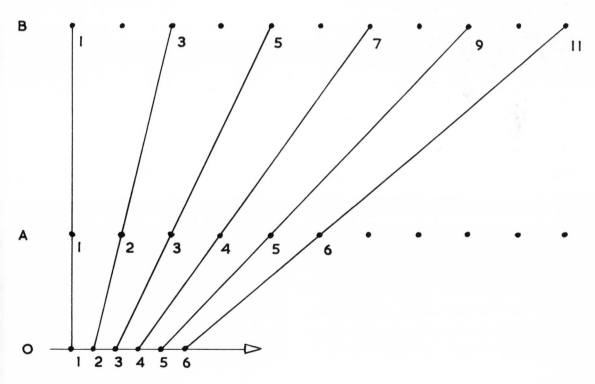

52 Moiré beat

an apparent magnification of movement running with the movement of the observer.

When two sets of straight lines are superimposed at right angles they form a square grid (53), and as the upper sheet is rotated the lines running diagonally suddenly emerge as the angle approaches 45° (54a). An enlargement of a diagonal is shown in (54b).

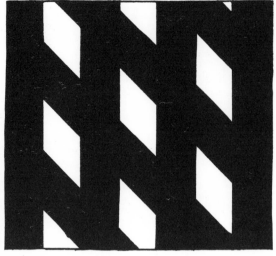

54 b *Enlargement of part 54a*

A gradual decrease in the angle between the original lines results in a corresponding increase in the angle between the vertical and the new diagonal lines (moiré fringes), and an increase in the distance between them (55a). The fringes also become wider and more insistent (55b). In (56) the fringes are more important visually than the lines.

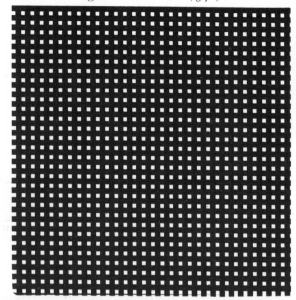

53 *Square grid*

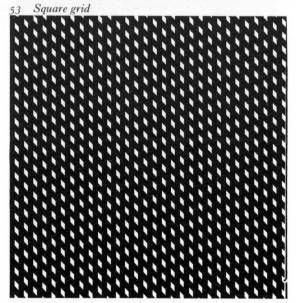

54 a *The diagonal emerges as the grid angle approaches 45°*

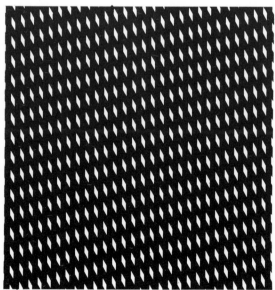

55 a *The diagonal angle increases as the grid angle decreases*

55 b Enlargement of part of 55 a

57 a and b Movement of the fringe

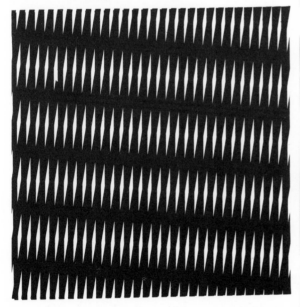

56 The moiré fringes (diagonals) are more insistent than the lines of the grid

57 b

At the angles used in the last two diagrams a slight horizontal movement of one of the sheets will give a very rapid vertical movement of the moiré fringes *(57 a, b)*, a magnification of fifteen to twenty times. Lines such as these can be purchased in transparent self-adhesive sheets from drawing office suppliers.

The beat effect referred to earlier also gives rise to magnification of the basic unit when two similar sheets are placed together, or one behind the other at a small distance. The smaller the apparent difference in distance between the units the greater the degree of magnification. If two lines are divided as in

39

(58), the length of the divisions in B being nine tenths those in A, the marks will coincide at every ninth unit on scale A. (This is the principle of the vernier scale on measuring instruments.) In scale C the divisions are four fifths the length of the basic scale, and the marks coincide at every fourth. When two sets of like units, lines, dots, etc, are placed one above the other, if the distance between them is small, the apparent distance between the units is almost the same in both cases and the degree of magnification is large, but as the lower set recedes from the upper the apparent difference in length increases, and the degree of magnification becomes less (59). Where the lines coincide from the observer's viewpoint the effect is light, and where each space in one set is blocked by a line from the other set the line is dark.

58 *Vernier division of two lines*

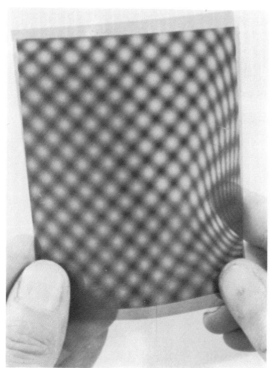

59 *a and b Diminution of scale magnification with increase of distance*

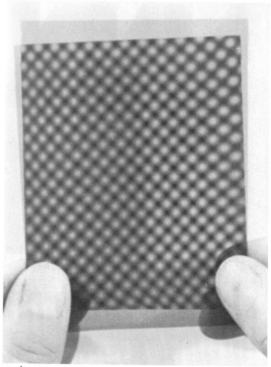

59 *b*

A similar effect occurs in a network. A half-tone screen is made up of small dots (60), and when two sheets of half-tone negative are placed together exactly in coincidence the effect is generally light (61a). If one sheet is moved half a unit relative to the other this cuts out most of the light. A slight rotation of one sheet produces a beat effect horizontally and vertically, the pattern of the dots being visible, and the degree of magnification depending on the angle between the two sheets (61 b and c). A straight line grid placed in front of a curved mirror will create a series of curved fringes, the beat occuring between the lines of the reflections, and a small movement of the grid or the mirror will give a large movement of the fringes. The half-tone screen placed on a slightly distorted surface such as aluminium cooking foil will produce fringes which virtually map out the surface (62). With the screen resting on the foil vigorous movement of the fringes results from the movement of the spectator.

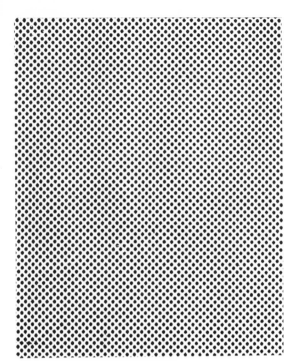

60 *Half-tone screen (enlarged)*

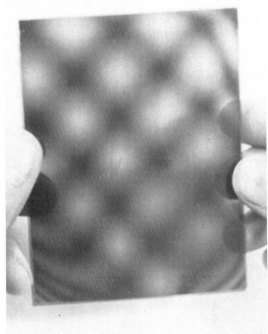

61 b *Half-tone screen, two layers small angle*

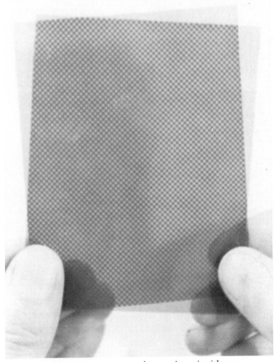

61 a *Half-tone screen, two layers in coincidence*

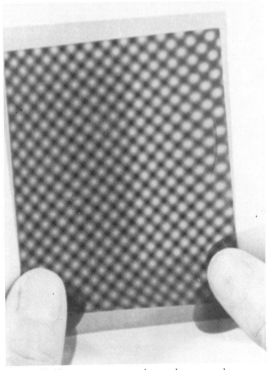

61 c *Half-tone screen, two layers larger angle*

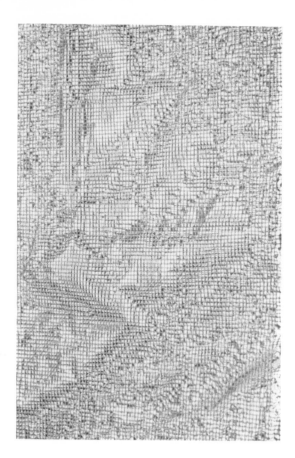

62 *Screen on aluminium foil surface*

Concentric circles and radiating lines crossed with circles or straight lines give a wide variety of curved effects *(63)*. When the two layers are separated by a few centimetres the shapes change rapidly. The top layer can be made up of tightly stretched cords, lines screen printed or engraved on acrylic sheet or on glass. The bottom layer can be lined paper or corrugated card with side lighting. Both layers may be organdie or similar light fabric, either stretched flat or with one layer in taut or freely hanging folds *(64 a to c)*.

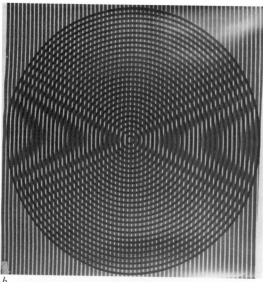

b

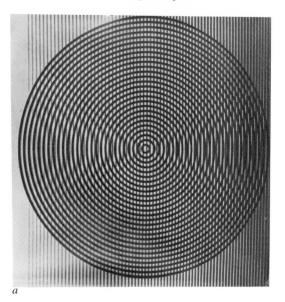

a

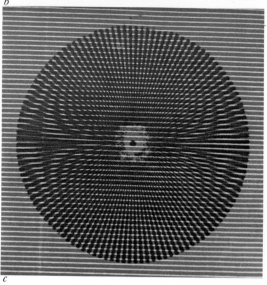

c

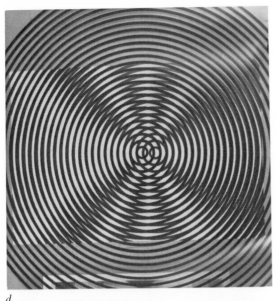

d

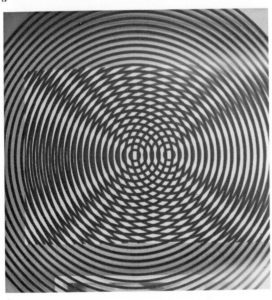

e

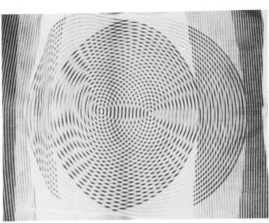

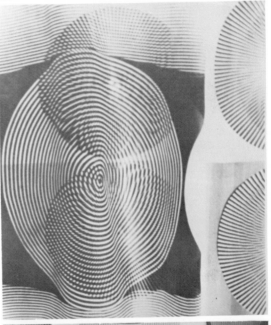

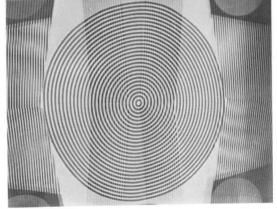

63 a–e *Moiré effects with curved and/or straight
lines*

64 a–c *Two layer effects* ▶

43

Although not a true moiré effect, a movement can be created with a series of edges and a background of lines *(65a)*. The black parallelogram is about 15 cms from the ground, and the thickness of the black and white lines is the same as the offset of the parallelogram (b), exaggerated here in proportion to the depth.

a b

65 *a Parallelogram on ground*
 b Parallelogram and parallel lines

When the parallelogram is seen as in *66a*, both edges are slanting. As the spectator moves to the right the parallelogram seems to move to the left, and the left edge gradually becomes indistinguishable from the black stripe on the ground (b), and the right hand edge enters the stripe which up to now has been in front of it, until in (c) both edges now appear to be vertical. A parallelogram with a small offset in proportion to the depth, and a correspondingly narrow line on the ground vibrates rapidly as the spectator walks past. A single thread stretched at a very slight angle above a lined ground will have dark spots running up and down it, and a pendulum of black thread or cord on a similar ground will have dark spots bunching closely together at the end of the swing *(67)*. A set of lines can be screen printed or drawn on acrylic sheet, and the whole sheet allowed to swing in front of, and parallel to, an appropriate ground *(68)*. *Cardenal (69)* and *Double Noir (70)* by Soto show similarities of construction. Rods are suspended on fine threads in front of a lined ground, and as the spectator moves before the composition or the rods move slightly, the moiré effect created between the rods and the ground causes flickering movements to appear, running up and down the rods (see diagram *67*). The

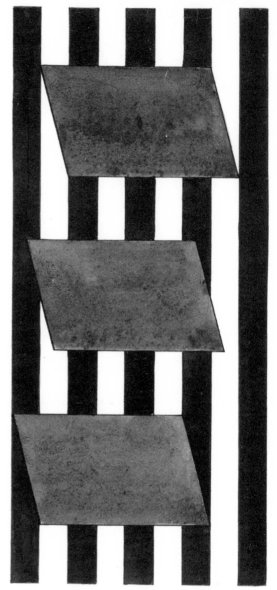

66 *a Parallelogram on lined ground : slanting ends*
 b Parallelogram on lines ground : changing ends
 c Parallelogram on lined ground : vertical ends

moiré effect in *V9 (71a)* and *VII (71b)* by Duarté occurs between the light source and the surface of the work. A transparent acrylic sheet has an integral black surface on one side and V-shaped incisions are engraved through this black surface into the clear part. Light is reflected from the edges of the groove, and the

67 *Pendulum on lined ground*

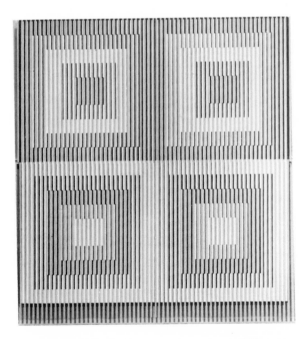

68 *Acrylic sheet swinging in front of ground. Structure Seulement by Yvaral (1 m square). Reproduced by kind permission of Kingston-upon-Hull Corporation and Ferens Art Gallery, Kingston-upon-Hull (Permanent Collection)*

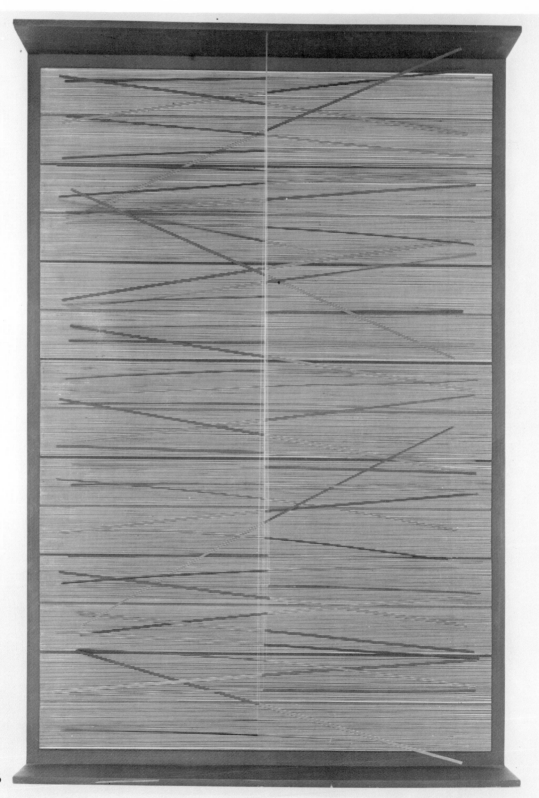

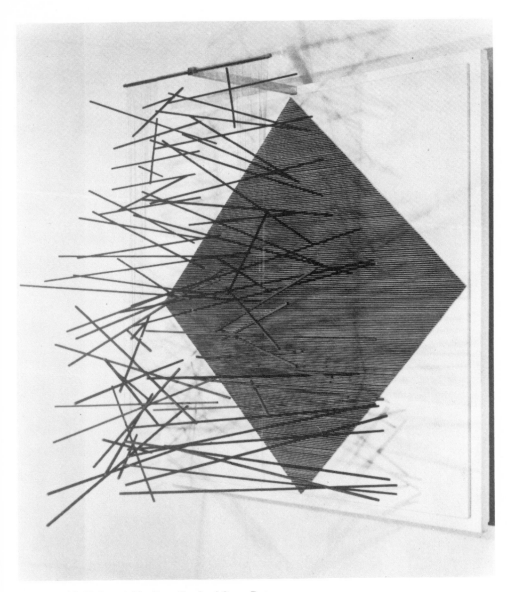

70 'Double Noir 1967' by Jesu-Raphael Soto. Repro-
duced by courtesy of Galerie Denise René, Paris

69 'Cardenal' by Jesu-Raphael Soto. Reproduced by
courtesy of the Trustees of the Tate Gallery, London

47

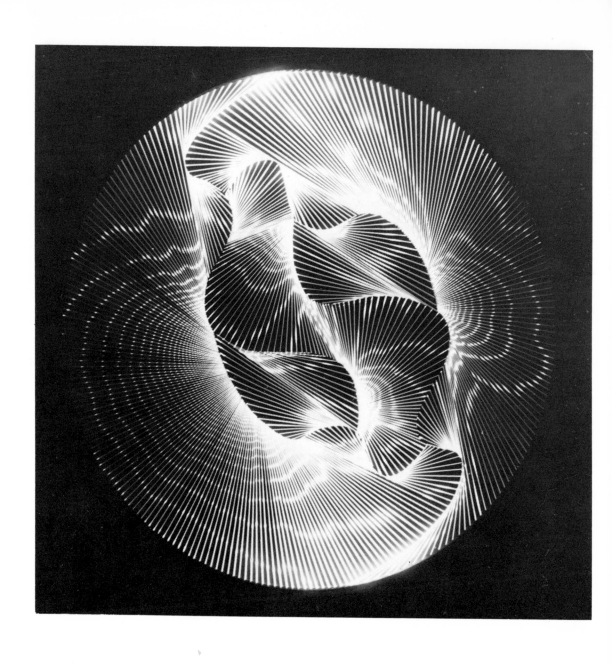

71 a 'V9 1963' by Angel Duarte. Reproduced by courtesy of the artist

48

Plate 1

1 Mixture of the three primary colours to form white light (see page 70)

2 The three primary colours mixed in pairs to form the three complementaries (see page 70)

3 Filter table (see page 71)

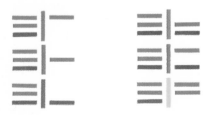

(a) Primary filters *(b) Complementary filters*

(c) Additive combinations of two primaries

(d) Subtractive combinations of two complementaries

(e) Primary complementary pair *(f) Two primaries*

(g) Three complementaries

4 White light reflected from white, coloured and black surfaces (see page 71)
(a) White light reflected from white, red and black surfaces
(b) Red spot on white ground illuminated with white light
(c) Red spot on white ground illuminated with red light
(d) Red spot on white ground illuminated with green light
(e) Red and green spots on white ground illuminated with yellow (red and green) light

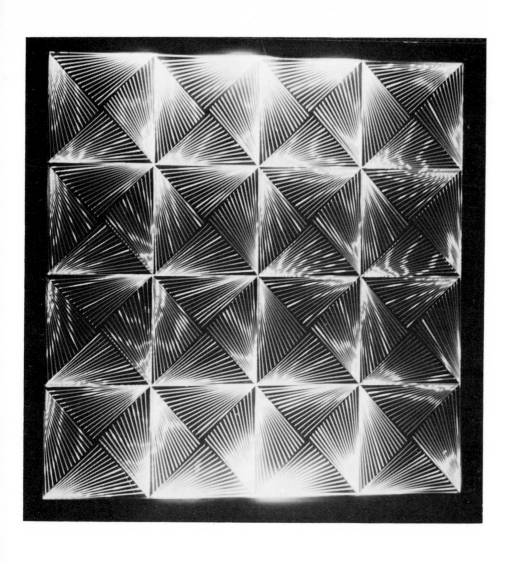

*71 b 'VII 1963' by Angel Duarte. Reproduced by
courtesy of the artist*

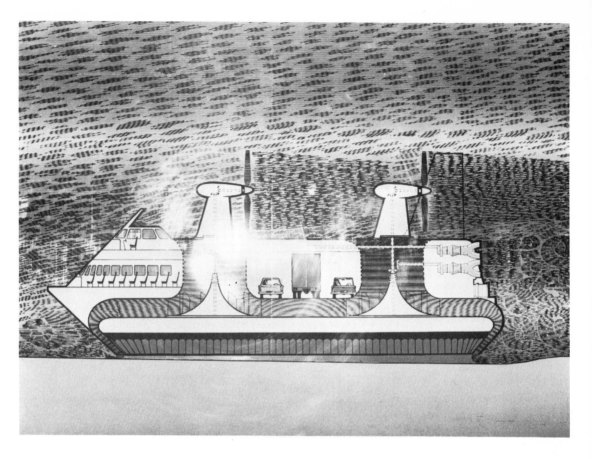

72 *'Hovercraft'. Reproduced by courtesy of B P Chemicals Limited*

varying angles of reflection from the radiating lines creates the moiré effect which moves as the spectator moves across the front of the composition. Figure 72 shows a very ingenious use of the moiré effect. The whole of the hovercraft is drawn on a transparent sheet, and the ducting for the air, the propellor blades and the background are covered with fine lines at varying angles. Behind the drawing a sheet with parallel lines moves slowly upwards, and this produces the effect of directional or rotational movement in the air streams, etc.

(b) Changing compositions

An actual change in composition can be caused by the movement of the spectator past the object, if the surface of the composition has vertical fins attached to it or is broken by

regular vertical triangular corrugations.

The latter method was used by several local Florentine and Venetian painters to make a portrait of Christ change into one of the Virgin. In both cases the blades or the corrugations can be anything from 3 mm to 30 mm or more deep ($\frac{1}{8}$ to $1\frac{1}{4}$ in.) depending on the scale of the work and the type of composition.

Two such surfaces are shown in plan in figure 73, the arrows showing the direction of viewing

73 a *Vertical blades or fins, in plan*

73 b Angled corrugations, in plan

needed to see the left hand sides completely
and unbroken. Figure *74 (a* and *b)* show the
appearance of both types seen from the left at
two different eye levels, and a gradual emer-
gence of the composition on the surface of *(a)*
and the right hand side of the corrugations of
(b) as the spectator passes from the left to the
centre *(c)*.

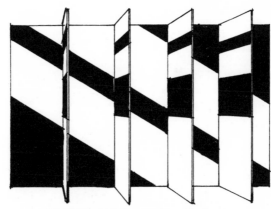

74 c (i) Vertical blades seen from the front

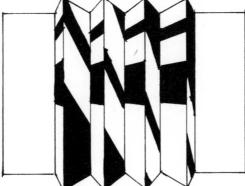

74 c (ii) Corrugations seen from the front

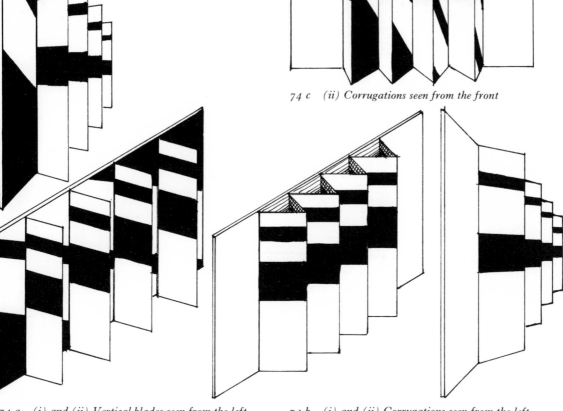

74 a (i) and (ii) Vertical blades seen from the left *74 b (i) and (ii) Corrugations seen from the left*

Physichromie numbers 6 and *141 (75* and *76)* by Carlos Cruz-Diez show small strips of cardboard placed at right angles to the ground painted in strong colours, which are then reflected by the ground. The actual colour perceived is an additive mixture of the colours on the strips, the proportions and the intensity of the component colours being determined by the distances from the strips and the angle of viewing. As the spectator moves these pro-

portions are continually changing. In *Composition 1965 (77)* by Yaacov Agam the surface of the painting is composed of parallel triangular corrugations. The compositions, whilst distinct from either side, integrate with one another when seen from the front.

76 '*Physichromie number 141' by Carlos Cruz-Diez. Reproduced by courtesy of Galerie Denise René, Paris*

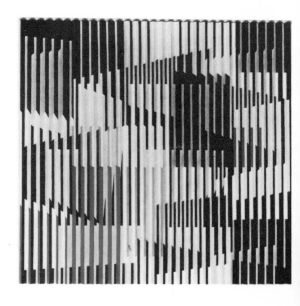

77 '*Composition 1965' by Yaacov Agam. Reproduced by courtesy of Galerie Denise René, Paris*

75 *Physichromie number 6 by Carlos Cruz-Diez. Reproduced by courtesy of Galerie Denise René, Paris*

(c) Direction of light on solids

The direction of light has considerable bearing on three dimensional perception. An object with a shadow on the side away from the light must be convex and vice versa *(78 a b)*. The shadows give the direction and elevation of the light, and the perceptive mechanism interprets the shapes without difficulty.

78 a Block with convex projection

78 b Block with concave depression

In the absence of any definite clue as to the direction of the light, such as may be the case in a darkened room with a single small area of projected light, the brain tends to revert to the most usual or logical interpretation. This is particularly noticeable on a close-up photograph of simple shapes if there is no direct evidence to show from which direction the light is coming. In this instance the brain usually interprets the photograph as if the light is from the upper left hand corner, as all right handed persons write and use tools with the light from that direction whenever possible to prevent the shadow of the hand from falling across the work. *79 (a)* and *(b)* show the same photograph, but *(b)* is inverted. The convex shapes of *(a)* appear concave in *(b)*, but if the book is reversed then the shapes appear to change. It requires a conscious effort to perceive *(b)* as a convex shapes with the light from the unusual position of bottom right. This interpretation is often used in stage sets.

79 a Convex spherical shapes

79 b Concave spherical shapes

Diagram *80a* is perceived as a row of holes through or into a wall, *80b* as three bevelled projections from the wall. The ambiguous figure in outline in *47* can be orientated by

80 a Three blocks with hollows

80 b Three blocks with projections

53

adding conventional shadow *(81)*. It is now very difficult to perceive it as other than three cubes below eye level. If however three cubes of card are made and illuminated with light from any of the three directions *(82 a, b, c)*, the cubes will appear to switch into either of the positions quite easily. This effect can be obtained even more easily if the three cubes are replaced by three rhombic dodecahedra, solids with twelve diamond shaped (rhombic) faces, *(83)*. (See appendix). A complete wall with a surface of these shapes can be made to appear to be swaying backwards and forwards, or to jump abruptly from one state to the other, or to appear flat *(84 a, b, c)*.

82 b Three cubes illuminated from left

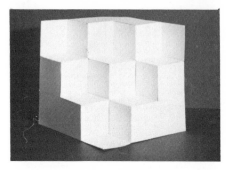

82 c Three cubes illuminated from right

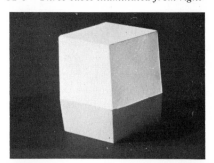

83 a (i)

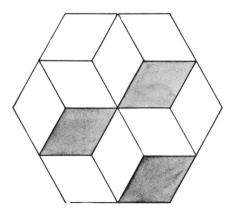

81 Three cubes

82 a Three cubes illuminated from above

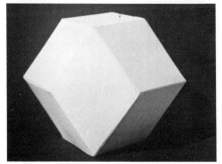

83 a (ii)

83 a (i) and (ii) Rhombic dodecahedron. Two aspects

54

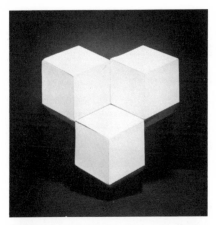

83 b (i)

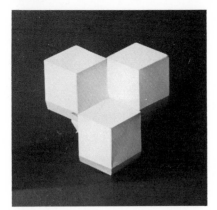

83 b (ii)

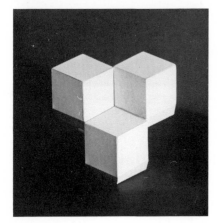

83 b (iii)

83 b (i), (ii) and (iii) Three rhombic dodecahedra illuminated from above, left and right

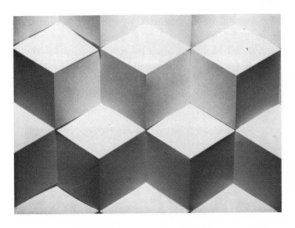

84 a Surface of rhombic dodecahedral facets, illuminated from above

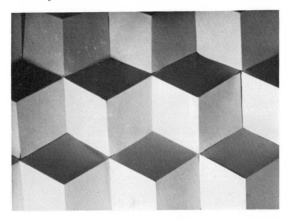

84 b Surface of rhombic dodecahedral facets, illuminated from bottom left

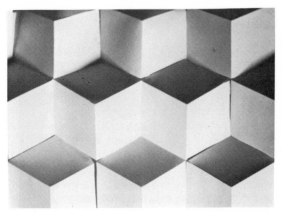

84 c Surface of rhombic dodecahedral facets, illuminated from bottom right

The block of hexagonal prisms (85a) with cross light from the left is given the appearance of a block of cubes by the position of the shadows (85b). The elongated twelve sided solid in diagram 86 appears to be a rectangular block either above or below the eye level, depending on the direction of the illumination.

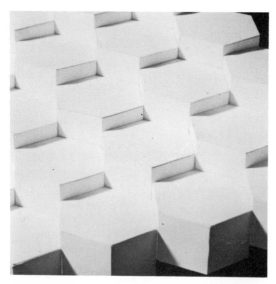

85 a Group of hexagonal prisms

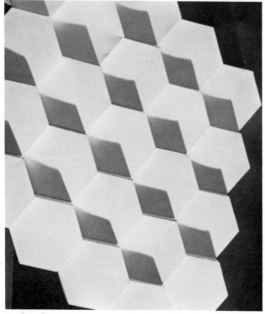

85 b Group of hexagonal prisms, illuminated from the side

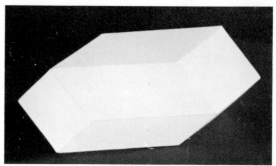

86 a Elongated rhombic dodecahedron, illuminated from above

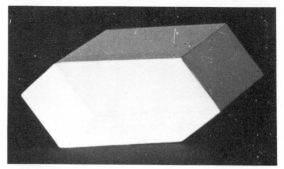

86 b Elongated rhombic dodecahedron, illuminated from left

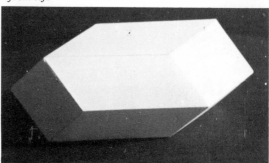

86 c Elongated rhombic dodecahedron, illuminated from right, to create the impression of a rectangular block changing its position relative to the eye level

(d) Apparent continuous movement

As the brain interprets the incoming information in the most logical way, an impression of continuous movement can be created by a series of discrete but sequential images (eg, the cine-film and television). If two lamps a few inches apart in a darkened room are

switched on and off alternately about two times per second, one light appears to move continuously back and forth between the two positions. A row of lamps lit sequentially at a steady rate will create the impression of continuous movement along the line. An interesting example of this illusion is the apparent rotation of a faceted re-entrant solid by illuminating it from a series of slightly different positions so that the shadows cast across the faces of the solid by its vertices are in accordance with its having rotated in a fixed light *(87)*.

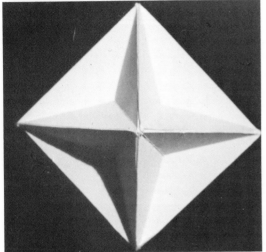

87 Octahedron with re-entrant faces illuminated from left

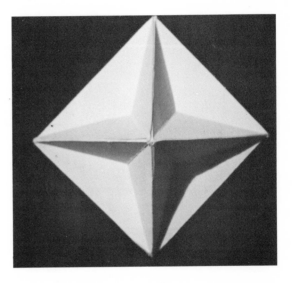

87 c Octahedron with re-entrant faces illuminated from right. With a greater number of light sources switched sequentially the octahedron appears to rotate

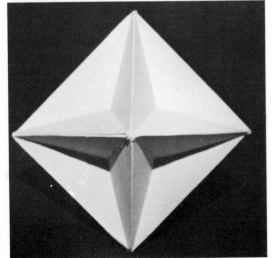

87 b Octahedron with re-entrant faces illuminated from centre

Part II 4 Light and simple optics

Light, for all practical purposes, travels in straight lines outward from the source, unless it is bent or deviated from its path by mirrors or lenses. The control of light in this way is very important in certain types of kinetic art. (See *chapter 6*).

The behaviour of light under these conditions depends on two phenomena, reflection and refraction, which occur when light strikes the interface between two materials of different density *(88)*. When a ray (A) travelling through a less dense medium strikes the surface of a denser medium, (eg, air to water or air to glass), part of the light is reflected (B) and part refracted (C).

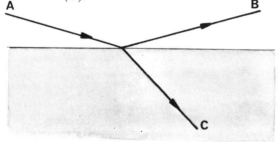

88 *Reflection and refraction*
A *incident ray* B *reflected ray* C *refracted ray*

(a) Mirrors

(i) Plane mirrors

The reflection in a plane mirror is straightforward. The reflected ray leaves the surface at the same angle to the vertical as the incident ray *(89)*. If the angle of incidence is changed by rotating the light source *(90)*, the angle of reflection is altered by the same amount; if the mirror is rotated *(91)*, the light moves through twice the angle.

When the reflection of an object (the image) is seen in a mirror, it appears to be as far behind the mirror as the object is in front *(92)*, the rays of light seeming to come in a straight line from the image.

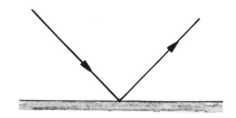

89 *Reflection in a plane mirror*

90 *Reflection in a plane mirror with the source rotated*

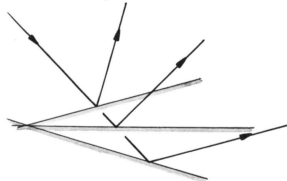

91 *Reflection in a plane mirror with the mirror rotated*

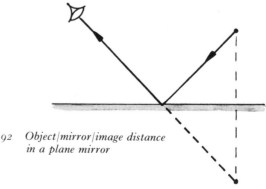

92 *Object/mirror/image distance in a plane mirror*

When two mirrors are placed at an angle to each other several images may be seen, the possible number depending on the angle between the mirrors. In diagram *93a*, with the mirrors at 90° the images 1 and 2 are seen by direct reflection, and image 3 is seen by reflections from both mirrors in sequence. As long as an image lies in front of the plane of a mirror, (or the line of a mirror extended beyond the point at which the mirrors meet), an image can be formed. Once the image falls in the angle behind both mirrors no further reflections are possible.

Diagram *93b* shows the images possible in two mirrors inclined at 60°. This is the principle of the kaleidoscope, which can be of considerable value in kinetic art (see *chapter 6*). Rays of light reflected once from each mirror are returned at a constant angle of deviation, which is twice the angle between the mirrors. Diagram *94a* shows mirrors at right angles, and *94b* mirrors at 60°.

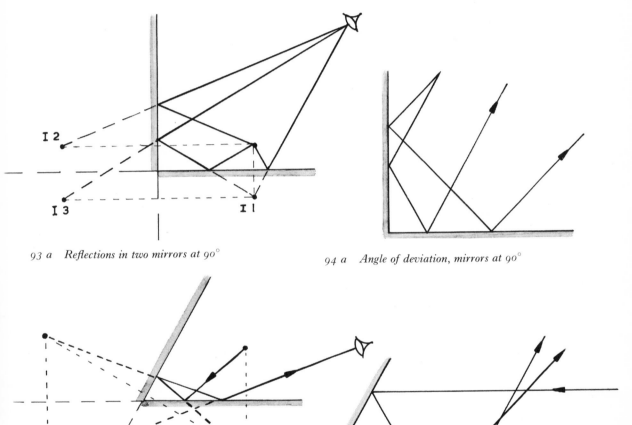

93 a *Reflections in two mirrors at 90°*

94 a *Angle of deviation, mirrors at 90°*

93 b *Reflections in two mirrors at 60°*

94 b *Angle of deviation, mirrors at 60°*

(ii) Curved mirrors (spherical)

A curved mirror may be considered as constructed from an infinite number of small plane mirrors. If the tangent to the curve is drawn at the point at which a ray meets the mirror, the ray can be drawn reflected as if from the plane *(95 a b)*. All rays parallel to the axis pass after reflection through the focus of the mirror in the case of concave mirrors *(a)*, and diverge as if from the focus in the case of the convex mirror *(b)*. In diagram *96 a, b*, C is the centre of curvature of the mirrors and F is the focus, which is half the distance of the centre of curvature from the mirror. P is the pole, the distance PF is the focal length, and the line PC is the axis of the mirror. A mirror is completely specified by the focal length and the diameter (usually quoted in mms). The longer the focal length the nearer the mirror is to a plane mirror, and the less the distortion of the rays of light.

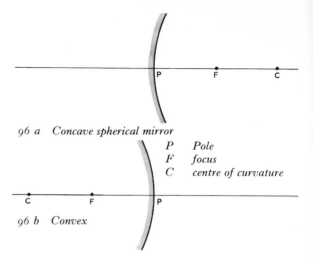

96 a Concave spherical mirror

P	Pole
F	focus
C	centre of curvature

96 b Convex

A concave mirror will produce an image which can be focused on a screen (see *chapter 6*). If the object is outside C the image is reduced and inverted *(97)*. As the object is brought nearer to the mirror the image recedes and becomes larger, until when the object is at C the image is the same size *(98)*. With the object between

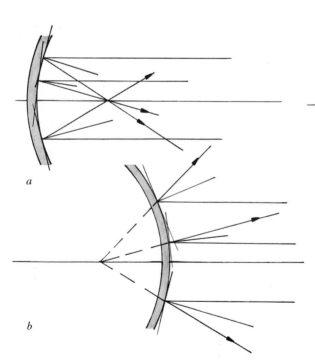

a

b

95 *Rays reflected from a concave (a) and a convex (b) spherical mirror as if from the tangential plane at the point of incidence*

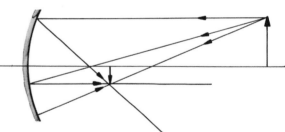

97 *Concave spherical mirror: image real, inverted, diminished*

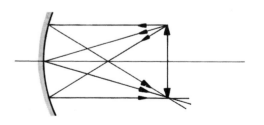

98 *Concave spherical mirror: image real, inverted, same size as object*

C and F the image is magnified but can still be focused on a screen *(99)*, the image becoming larger rapidly as the object approaches F. When the object is inside F the image is now erect and magnified, but is behind the mirror and can no longer be projected onto a screen. This is the type of magnifying mirror used for shaving or make-up *(100)*.

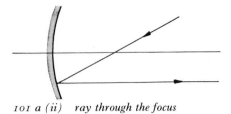

101 a (ii) ray through the focus

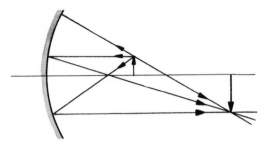

99 Concave spherical mirror : image real, inverted, magnified

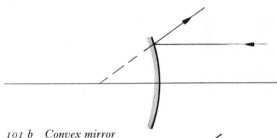

101 a (iii) ray through the centre of curvature

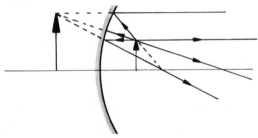

100 Concave spherical mirror : image virtual, erect, magnified

The position of any image can be found by tracing the paths of three rays of light from one point of the object. The ray parallel to the axis passes through the focus F *(101a (i))*, or apparently comes from F *(101b (i))*. A ray passing through F *(a ii)* or going towards F *(b ii)* is reflected parallel to the axis. A ray travelling towards C is reflected back along its own path *(a iii)* and *(b iii)* as it is meeting the mirror perpendicularly.

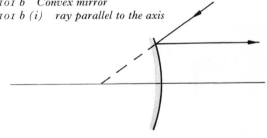

101 b Convex mirror
101 b (i) ray parallel to the axis

101 b (ii) ray through the focus

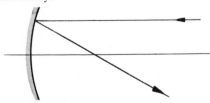

101 a Concave mirror
101 a (i) ray parallel to the axis

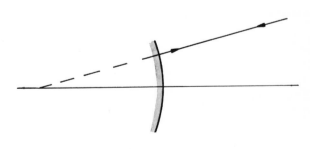

101 b (iii) ray through the centre of curvature

A convex mirror cannot form an image which can be projected. Wherever the object is placed the image is always erect, diminished, and behind the mirror *(102)*. A typical example of a convex mirror is the wide-view car driving mirror.

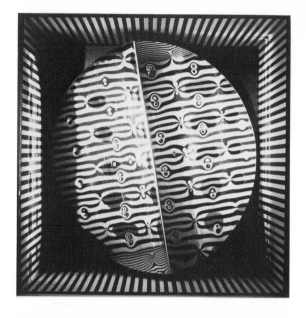

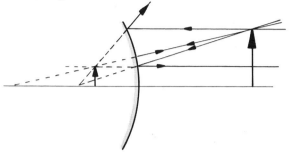

102 Convex spherical mirror: image virtual, erect, diminished

In *Trame Alternée (103)* by Julio Le Parc the central disc, folded into a blunt wedge shape, has small convex and concave areas which behave as spherical mirrors formed in the highly polished metal. As the whole disc rotates inside the striped cubical box the reflections of the lines are continually changing shape. *Continual Lumière (104)* and *Continual Lumière Cylindre (105)* both by Julio Le Parc show slowly moving beams of light reflected from cylindrical metal mirrors. *Continual Lumière* utilises both the concave faces and the convex backs of the mirrors, which project horizontally from a vertical ground and face downwards towards the light source at the base. *Continual Lumière Cylindre* has one large ring mounted in a similar way and the beams are reflected within the ring.

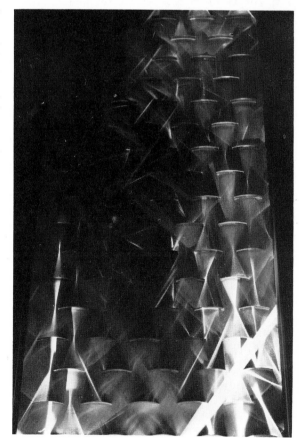

Above right
103 'Trame Alternée' by Julio Le Parc. Reproduced by courtesy of the artist

104 'Continual Lumière' by Julio Le Parc. Reproduced by courtesy of the artist

62

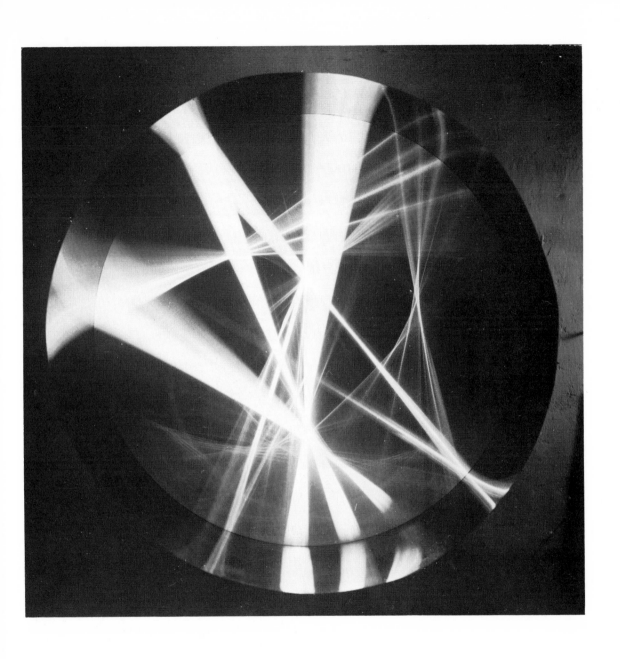

105 'Continual Lumière Cylindre' by Julio Le Parc.
Reproduced by courtesy of the artist

63

(b) Lenses

Spherical lenses behave in very much the same way as spherical mirrors, except that the light is transmitted through the lens and not reflected. Three rays are used to trace the position of the image, the two parallel to the axis and through the focus respectively being the same as those in the curved mirror, the third ray being replaced by a ray through the centre of the lens, which is for all practical purposes unaffected and travels straight on (106 a b).

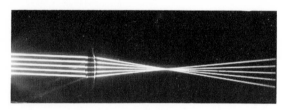

106 a (i) Convex lens, paths of three rays to determine the position of the image

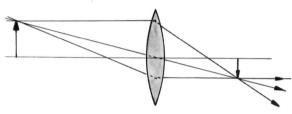

106 a (ii) Paths of light through convex lens

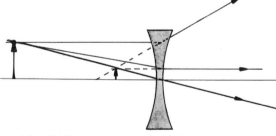

106 b (i) Concave lens, paths of three rays to determine the position of the image

106 b (ii) Paths of light through concave lens

(i) Convex (or converging) lenses

The convex lens is similar to the concave mirror, as it produces an image which can be focused on a screen.

An object outside C (ie, twice the focal length of the lens) will produce a diminished inverted image (107). As the object approaches the lens the image recedes from it until at C (2f) the image is the same size as the object. This is the shortest possible distance between the object and the image (108). Between C and F the image is still inverted but is now magnified (109), (this is the slide projector) and inside F the image is magnified, erect, but on the same side of the lens as the object, and cannot be projected onto a screen (110) (the simple magnifying glass).

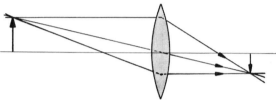

107 Convex lens : image real, inverted, diminished

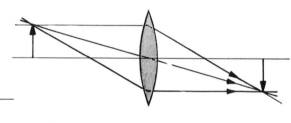

108 Convex lens : image real inverted, same size as the object

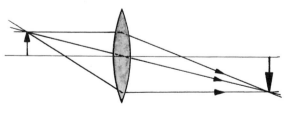

109 Convex lens : image real, inverted, magnified

Plate 2

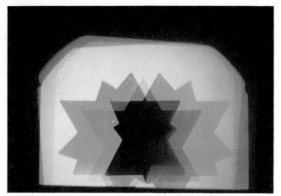

1 Three primary colours overlapping on a back projection screen. (Hard-focused not soft-focused as in text. See page 73)

2 Three faceted solids in different combinations of light (see page 76)

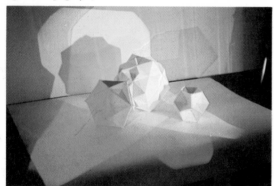

(a) Primary colours

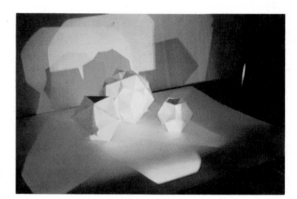

(c) Warm range

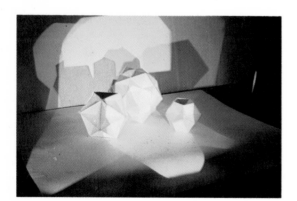

(b) Complementary colours

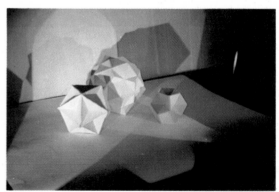

(d) Cool range

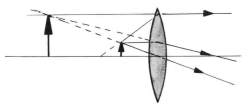

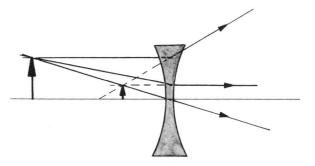

110 Convex lens : image virtual, erect, magnified

(ii) Concave (or diverging) lenses

The image formed by concave lenses, like the convex mirrors, are always erect, diminished, and cannot be projected *(111)*.

111 Concave lens : image virtual, erect, diminished

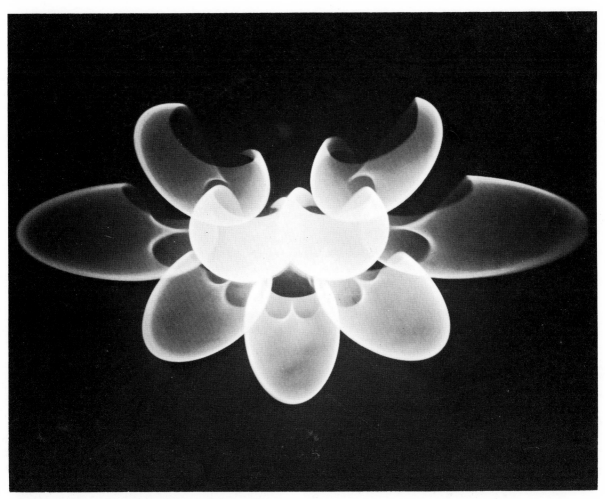

112 'Box No. 3' by John Healey. Reproduced by courtesy of the International Lighting Review

(c) Cylindrical lenses

Cylindrical lenses are parallel-sided rectangular lenses, with a cross-section similar to a spherical lens *(113 a b)*. The convex cylindrical lens will focus rays of light to a point in one plane, but in the other at the right angles to it the rays are undeviated *(114)*. The image formed from a parallel beam of light will therefore be a bar parallel to the axis of the cylinder, in contrast to the spherical convex lens which would form a circular spot under similar circumstances. The concave cylindrical lens diverges the beam in one plane only in a similar way *(115)*.

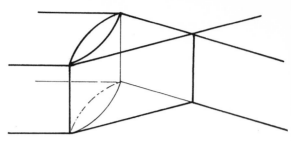

114 Path of light through convex cylindrical lens

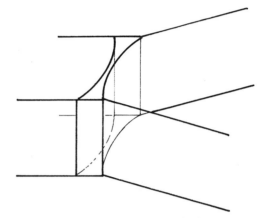

115 Path of light through concave cylindrical lens

Lenses may be combined to form lenses of different powers. Two or more lenses of the same type increase the convergence or divergence of the emergent rays, *(116a)* convex lenses, *(116b)* concave lenses. The two lenses of different types can be made to increase or decrease the width of a beam but leave it otherwise unaltered.

113 a Convex and concave cylindrical lenses showing effect on line of light

113 b Convex and concave cylindrical lenses showing the shape

116 a Two convex lenses increase the convergence

66

116 b Two concave lenses increase the divergence

Diagram *117a* shows a parallel beam enlarged, and *117b* a similar beam reduced in width by combining convex and concave lenses.

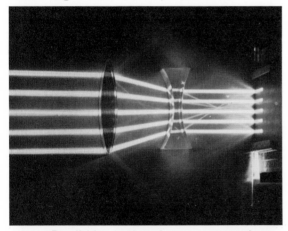

117 a Parallel beam enlarged, concave-convex lenses

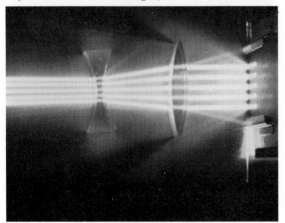

117 b Parallel beam reduced, convex-concave

(d) Prisms

The two most common types of prisms are the 60° and the 90°-45°-45°. The 60° is used for dispersion, breaking up white light into the spectrum *(118)*. The light of shortest wavelength, blue-violet, is deviated more than the longest, red.

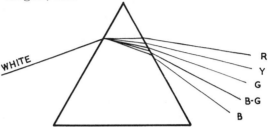

118 Dispersion of white light through prism

The right angled prism can also be used in this way, when the angle of 45° is used as the refracting angle. The more useful property depends on total internal reflection, which may be employed in two ways *(119 a b)*. In both prisms the rays meet the glass-to-air surface at 45°, slightly more than the critical angle (ie, the angle at which reflection into the denser medium replaces refraction into the less dense medium). This interface acts as a perfect mirror and turns the ray through 90° or 180°. Lenses and prisms of all shapes can be cut from acrylic sheet or turned from an acrylic rod,

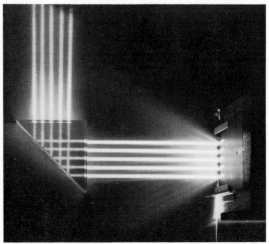

119 a 45° prism, 90° deflection of light

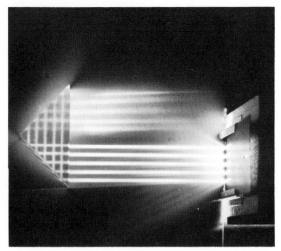

119 b *45° prism, 180° deflection of light*

provided that the working surfaces are well polished. Acrylic sheet can be bought in thicknesses up to 25 mm. in both sheet and rod. If a light is projected along the length of a rod the whole rod glows slightly, (unless it is very well polished,) and most of the light emerges at the far end, which may be turned or sawn to make a miniature lens *(120)*. Even when it is bent into a circle the light still traverses the full length of the rod, internal reflection keeping most of the light within the rod *(121)*.

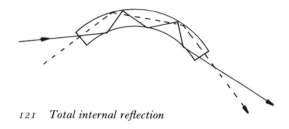

121 *Total internal reflection*

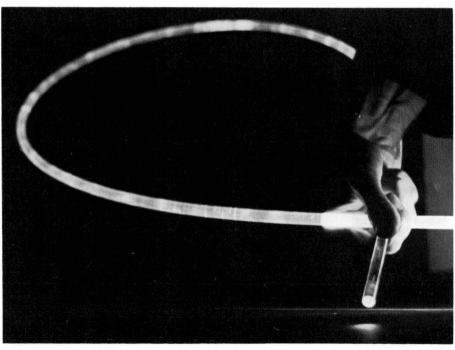

120 *Total internal reflection*

5 Colour

Light is a form of electromagnetic radiation, and is part of a vast spectrum of radiations extending from long wave broadcasting downwards; through television, radar, infra-red (heat) visible light, ultra-violet (including soft X-rays), hard X-rays, and finally gamma rays (nuclear reaction), *(122)*. The whole of the visible light represents a little less than an octave out of some seventy octaves, with a wavelength of between 4 and 7 ten-thousandths of a millimetre, and a frequency of between 7 and 4 hundred million million vibrations per second. The colour sensitive receptors in the eye are 'tuned in' to wavelengths of blue, green, and red light *(123)*, and whilst they are most sensitive to the wavelength to which they respond, they can be stimulated by light of wavelengths on either side, the response falling off as the wavelengths become increasingly different. This is exactly analogous to tuning to overlapping stations on the radio. At a certain point one station will predominate, and as the tuning is altered a second station blends with the first, and gradually replaces it. A pure blue light will stimulate the blue receptors, and a green light the green receptors, but a blue-green light will stimulate both kinds, and the brain will register the single colour of blue-green.

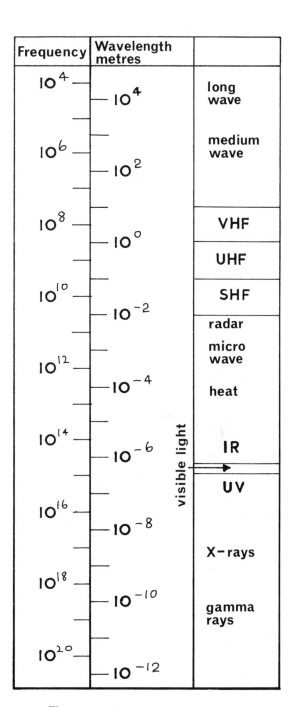

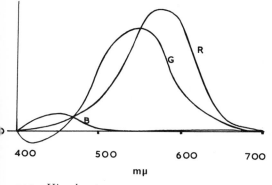

123 Visual response curve

122 Electromagnetic spectrum

(a) Three-colour theory

Newton proved that white light is a combination of all the colours of the spectrum by passing a ray of sunlight through a prism, resolving the white light into its component colours, and then recombining the individual colours into white by passing the ray through another prism placed in the opposite way to the first *(124)*.

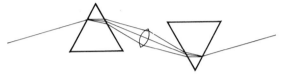

124 Two prisms used to disperse white light and recombine the colours into white light

The seven colours of the rainbow listed by Newton were reduced to three by Young, and this was corroborated by Helmholtz a short while later. Young and Helmholtz demonstrated that white light and all the spectral colours could be formed from three colours of suitable relative intensities, one each from the red, green, and blue wavelengths. There are several groups of three colours which will give this effect, but the three purest colours have been precisely specified, and are used as the basis for the great majority of work with coloured light, ie, stage lighting, colour photography, colour television, and, in a different way, three colour printing. The three colours are primary red, with a wavelength of 700 mμ, primary green 546.1 mμ, and primary blue 435.8 mμ. Although light of wavelengths from 380 to 780 mμ may be seen, the two extremes, 380 to 400 and 700 to 780 are very dark *(125)*.

125 Colour spectrum and wavelength

(b) Additive mixtures of light

When lights of the three colours red, green and blue are projected onto a screen so that the colours overlap, the resulting mixture is white light (see *colour plate 1*). If any two lights are added together the colours produced are termed complementary colours, as each of the colours so formed would, with its respective primary, make up white light. The three colours are yellow, magenta and cyan (formerly called peacock blue); yellow being a mixture of red and green light; magenta, red and blue; and cyan, blue and green (see *colour plate 2*).

(c) Subtractive mixtures of light and pigments

(i) Light

The complementary colours may also be regarded as white light minus a primary; yellow being white minus blue, magenta white minus green, and cyan, white minus red. The filters giving the complementary colours are therefore called subtractive; as each one removes the unwanted primary from the white light.

(ii) Pigment

Pigments create the sensation of colour by subtracting from white light the colours not required, absorbing them as heat, and returning the light of the colour required. They work by reflection in the same manner as the complementary filters work by transmission. When two pigments are mixed each one absorbs part of the spectrum, and the overall level of reflected light is considerably reduced. This is similar to passing light through two successive complementary filters.

(d) Filters

There are two types of filter, the interference filter and the absorption filter. The former works by causing light of the undesired wavelengths to interfere destructively with itself, the crests and troughs of the waves nullifying each other. As energy cannot be destroyed, the transmitted light is correspondingly increased in brilliance, and the filter itself remains cool. It is, however, expensive to produce. The absorption filter, such as cinemoid sheet, or the old stage gelatine, absorbs the unwanted colours as heat, and transmits approximately the required light. The absorption filter is not

as accurate or as well defined as the interference filter, but is cheap to produce, and sufficiently accurate for most uses.

The results of combining lights additively and subtractively are summarised in the filter table on *colour plate 1* opposite page 48. (a) and (b) show the action of the primary and complementary filters singly. (c) is the additive combination of any two primary filters. (d) gives all the subtractive combinations of any two complementary filters. (e), (f) and (g) all give no emergent light in the three possible ways: (e) a primary-complementary pair, (f) any two primary and (g) all three complementary.

(e) Reaction of light on pigment

Any surface appears to be white, coloured or black according to the amount and the wavelength of the light reflected from it when it is illuminated with white light (see *colour plate 4a*). A red spot of paint on a white ground will reflect only red light, whilst the ground is capable of reflecting all lights equally (see *colour plate 4b*). If instead of a white light a red light is directed on to the spot and ground, both the red spot and the white ground will reflect exactly the same rays (assuming that the pigment is matched to the filter), the red spot becoming invisible (see *colour plate 4c*). Owing to the property of the perceptual system known as colour constancy, (see section f), the brain tends to interpret the ground as white, automatically compensating for the red light as the whole visual field is illuminated with red light. The red spot is therefore interpreted as white along with the ground.

When a green light is used instead, the ground is still interpreted as white because it reflects a large amount of green light, but the spot, absorbing all the green light and having no red light to reflect, appears black (see *colour plate 4d*) (see *chapter 6 (d)*). A yellow light would enable both red and green spots to be seen in their true colours, but the ground may appear to be a yellowish white instead of white (see *colour plate 4e*).

Similar effects can be demonstrated with red, blue and magenta lights, and blue-green and cyan, but the most spectacular effects are obtainable with red, green and yellow.

(f) Colour constancy

Objects are always perceived in relationship to their surroundings. A piece of white paper in a dim light may actually reflect less light, objectively measured, than a piece of black paper in a bright light, but would always look white as it is reflecting a much higher proportion of light than its immediate surroundings. A window at dusk appears lighter than the wall of the room in which it is set, but darker than the wall when the room light is switched on. The visual mechanism is reacting to the ambient illumination, and not to a specific part of the visual field.

Thus a garment known to be white will always be perceived as white, whether the light be bright or dim, white or coloured, as the brain automatically compensates for the overall intensity and colour of the illumination. The white ground referred to in section (e) will always appear white, whether in red, green or yellow light (unless sufficient red and green colour is visible in yellow light to give a colour reference, which does in fact occur in a few cases).

The relative brightness of the illumination does çause a slight change of colour balance. Under conditions of gradually increasing intensity colours tend towards blue or yellow, according to their position in the spectrum. Blue-violet and blue-green become more blue, green-yellow and orange-red become yellow *(126a)*. With decreasing intensity green-blue and green-yellow become greener, blue-violet and orange-red become more deep red *(126b)*.

126 a Benzold-Brücke effect, illumination increasing
126 b Benzold-Brücke effect, illumination decreasing

71

(g) Colour focusing

As rays of light of different wavelengths are refracted at different angles by a lens, the various colours will come to a focus at different distances from the lens, blue focusing nearer to the lens than red *(127)*. This occurs in the eye, the difference between the two points being approximately 0.6 mm. The eye is most sensitive to yellow light, and yellow light is the only one which is correctly focused. Blue therefore focuses in front of the retina, and red behind it *(128)*. This is the same as the effect produced by two objects at different distances *(129)*, and is a possible explanation of red seeming to advance, and blue to recede. When well-defined areas of red and blue (or red and green) are placed together, the eye is endeavouring to accommodate for what is in effect two different distances simultaneously, and the colours seem to flicker, and may cause a mild eye strain.

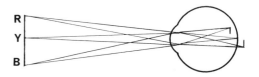

128 Colour focusing in the eye with red, yellow and blue rays

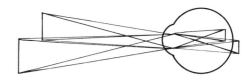

129 Focusing in the eye with two objects at different distances

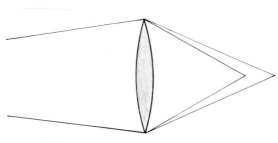

127 Colour focusing

6 The use of light

Light itself is invisible, and becomes visible only when it strikes an object and is reflected from it. The object may be extremely small; a globule of water vapour in a thick mist, a particle of dust or smoke, and by itself almost invisible, but a large number together forms a translucent mass through which the path of light is made visible by the reflections from the minute solids.

Coloured lights from several projectors can cover a white wall with a sequence of changing colours, or can illuminate carefully planned three dimensional shapes. If these shapes are sharply faceted or moulded into curves and hollows the sequence of coloured lights will produce areas of colour, hard or soft edged, covering the solid. The projected light may be hard and crisply focused, giving well defined edges to shadows, or may be diffused through pin-head acrylic sheet or frosted glass, which softens the shadow edges and subdues the surface variations.

The shadow of objects can be used projected on to the back of a translucent screen to form an area of colour which varies with the overlap of the shadows. The intensity of the light, and hence the colour, may be varied by passing the light through lenses to concentrate some areas of it at the expense of the immediately adjacent areas.

Movement is added to the display by sequential switching of the lights or by rotating two or three dimensional forms behind a back projection screen.

Pigment and light combined can be used to change two dimensional patterns or three dimensional shapes, or to create or destroy the effect of three dimensions on flat or relief surfaces. These surfaces themselves may be constructed of translucent material which can be front or back illuminated to obtain differing effects from one display.

(a) Projection

(i) Front projection

Front projection on to a screen is the most obvious and straightforward way of using projected light, but it is limited by the necessity for having a low level of general illumination in front of the screen for the display to be visible, and by the need for a clear and permanently uninterrupted throw from the projectors to the screen.

When several projectors are soft-focused in overlapping areas on to a screen, dimming or sequence switching will result in irregular patches of mixed colour. If only the three primary colours of red, green and blue are used in the projectors, the complementary colours of cyan, magenta and yellow will appear as well as white light and the three primaries. (See *colour plate 2*).

The texture of a surface can be used to enhance the effect of projected light. A light shining sideways across a corrugated surface (corrugated cardboard painted white) illuminates one side of the corrugations, and the alternating bright and shadow areas increase the apparent depth of the hollows *(130a)*. A light shining

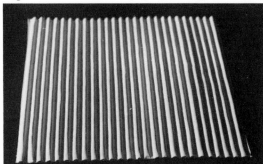

130 a Corrugated card illuminated from the side

130 b Corrugated card illuminated from the end

73

parallel to the corrugations will have much less effect, and will flatten the surface *(130b)*. A rotating circle of card will therefore change colour if it is illuminated by two differently coloured projectors at right angles, or will change from bars of two distinct colours to a mixture of the two colours with two projectors opposite each other *(131 a b)*.

131 a Corrugated card illuminated by two projectors at 90°

131 b Corrugated card illuminated by two projectors at 180°

Alternatively, a relief surface built up of geometric units can have changing cross lighting (as in *chapter 3*) but with the emphasis on colour instead of on form. The relief area can be swept by a spot of light, using a rotor/stator mask or a rotating spotlight.

(ii) Back projection

Back projection is less restricted in use than front projection, but the translucent screen is usually much more expensive to make than a screen for front projection. The main advantage of back projection is that it can be used in daylight, provided that the screen itself is not directly illuminated. A small self-contained display need be no more than a foot deep if it uses the rotor/stator system, and even with projection can be fitted into two feet or less. There can be no interruption in the throw, as nothing can pass between the projector and the screen: the chief restriction is one of size.

Back projection screens can be made from several different materials. Ground glass is very efficient, but easily broken; opal acrylic sheet transmits less light, and is expensive, but with reasonable care it is unbreakable. Tracing paper stretched in a frame or attached at the edges to clear acrylic sheet or glass is quite effective, and though it is very vulnerable when it is unsupported, it is very cheap. Organdie stretched in a frame can sometimes be useful, but the light sources tend to be visible through the weave of the fabric. A household sheet makes a reasonably efficient large scale screen, but it is impossible to obtain sharp definition or fine lines on it, and the light loss is fairly high. Simple changes of light are better with back projection than with front, but the most effective use of back projection is with shadows cast by solid forms. A cylinder with its axis placed vertically will give the same shadow regardless of the direction of the light *(132)*, apart from the difference in width or the change of the shadow edge caused by the change in the angle of the beam and the relative distances of the projector and cylinder from the screen. Any other solid will cast shadows of different proportions or shapes from different angles. A cube, diagram *133*, will cast a square or rectangular shadow, depending on whether the width of the shadow is the length of the side or of the diagonal of the cube. A thin flat solid will cast a wide or narrow shadow with the projectors

132 Shadow of cylinder (back projection)

133 *Shadow of cube (back projection)*

at right angles, ie, parallel to its axes *(134 a b c)*. Solids with slanting edges (except for a simple pyramid) will change considerably, especially if there are projecting vertices on the solid.

If two projectors have complementary filters the shadows will be on a white ground, eg, green/magenta, the shadows will be magenta or green on a white ground. With any two primaries, the shadows will be on a ground which is the complementary of the third colour. eg, green/red, the shadows will be red or green on a yellow ground.

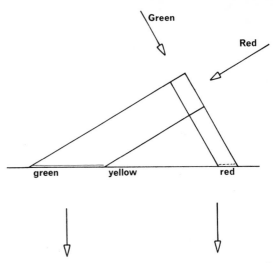

134 c *Primary shadows on a complementary ground from two projectors with two different primary filters*

The position of the object between the projector and the screen influences the sharpness of the shadow edge. When the object-screen distance is small compared with the projector/object distance the shadow edges are sharp *(135a)*. When the object/screen distance is large compared with the projector/object distance the shadow edges are soft, as the area illuminated by at least part of the light from the lens occupies a greater proportion of the total shadow area *(135b)*.

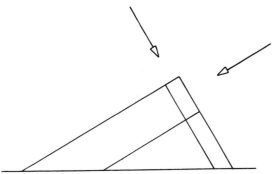

134 a *Unequal shadows cast by rectangular block*

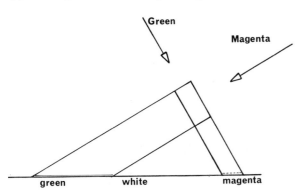

134 b *Coloured shadows on a white ground, from two projectors with a primary-complementary pair of filters and one object*

135 a *Hard shadow edge*
135 b *Soft shadow edge*

Though these principles are in themselves quite simple and obvious, there is a very wide field waiting to be explored in the application of these principles. Sequential switching of projectors, rotor/stator light movement, and rotation of the solid or solids by small motors all add to the creative possibilities of the medium of back projection.

(b) Three-dimensional solids

(i) Static

The intensity with which a given light illuminates an area depends partly on the angle at which the light is incident upon the surface. A parallel beam falling almost vertically on a surface illuminates an area little larger than the lens through which it passes, and the intensity is therefore high (136 left). As the angle of incidence increases, and as the light is assumed to be constant, the intensity of the illumination will decrease according to the sine of the angle (136 right).

136 High and low intensity of illumination, varying with the angle of incidence from beams of equal size and intensity

If two projectors with primary filters both illuminate the same area and are at the same angle of incidence, then, assuming that the light intensity of both is the same, the area will appear to be the appropriate complementary colour (137). If the angles of incidence are greatly different one projector will predominate to a degree dependant on the area over which the light from each projector is spread (138), and the resulting colour is between that of the complementary colour and the stronger primary.

A facetted solid, eg, a dodecahedron or an icosahedron, will receive light at different

angles from different projectors placed round it, and will therefore display mixtures of colours on its illuminated faces. (See *colour plate 2* facing page 65.)

A heavily textured or a modelled area, when cross-lit from different angles will show a wide variety of colours on its facets.

137 Complementary colour from two primaries

138 Intermediate colour from two primaries of unequal intensity due to different angles of incidence

(ii) Moving solids

If faceted solids, either standing on a turntable or suspended from above, are rotated slowly in the beams from two or three projectors, the proportions of colours falling on the faces are continually changing. With careful planning of faces and colours the appearance of the solid can be made to change completely, concave shapes appearing to become convex, and vice versa, as the balance of the colours on the facets changes. Solids with re-entrant faces are usually most useful for this type of display.

In *Chronos 8 (139)* by Nicolas Schoffer the whole structure revolves, and the small reflectors rotate independently. *Sphere Trame (140)* by François Morellet provides continually changing movement through the three-dimensional cubic grid or lattice which, when rotated, gives multiple shadows and reflections in the light from the powerful projectors.

(c) Lenses, prisms and mirrors

The path of light rays through lenses and prisms and the reflections of rays from mirrors cannot be seen under normal conditions.

If light is projected through cylindrical lenses which are standing on a white ground or on a translucent screen (ie, opal acrylic sheet or tracing paper on glass), the tracks of the rays are then visible from above or below the surface respectively. By using several elements linear compositions may be built up *(141 a-i)*. A static display can be given movement by moving the first lens in the path of the beam as in diagrams *(141 a-g)*, or by rotating the whole composition on a turntable attached to the spindle of a synchronous clock motor or hung from a similar motor overhead.

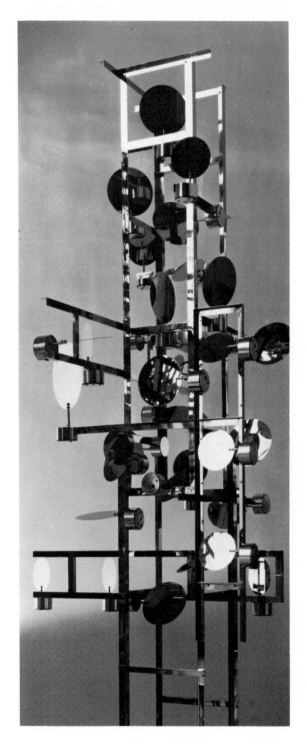

139 '*Chronos 8' by Nicolas Schoffer*

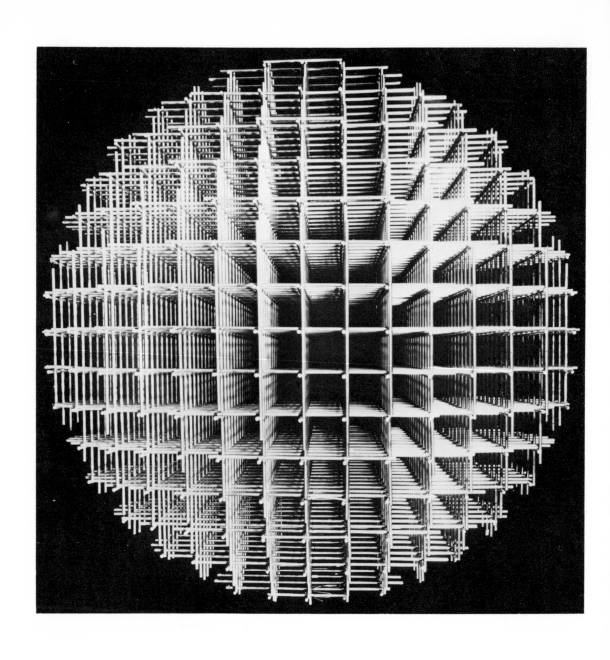

140 'Sphere Trame' by François Morellet. Reproduced by courtesy of Galerie Denise René, Paris

78

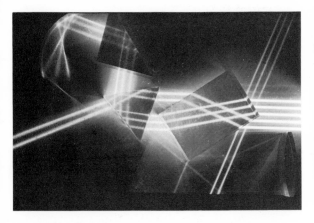

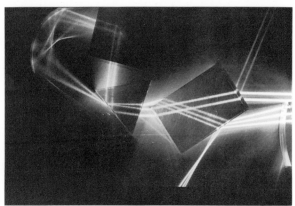

141 a–i *Random paths of light between perspex lenses
and prisms in a multiple beam*

d

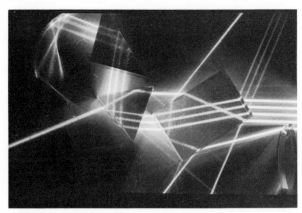

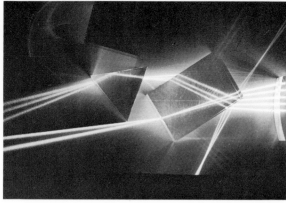

b

e

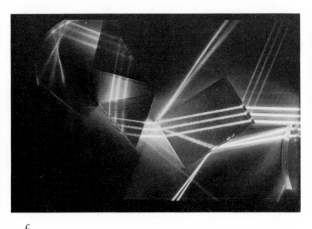

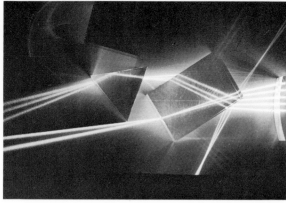

c

f

79

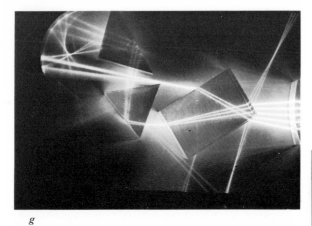

g

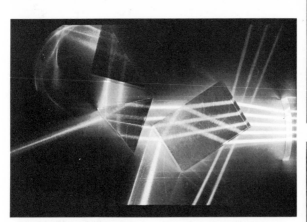

h

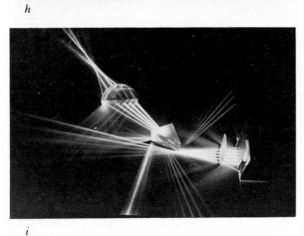

i

142 a–g *Apparently three-dimensional shapes created by projecting a beam of light through cylindrical lenses at irregular angles to the axes of the lenses* ▶

Other compositions can be formed from cylindrical lenses, singly or in groups, which are placed at angles other than a right angle to the beam of light. The resulting spread of light creates strongly three dimensional shapes. Figures *142 a-g* show both convex and concave lenses used in this manner, and figures *143 a-b* shows prisms used similarly. (See also *colour plate 2* facing page 65.)

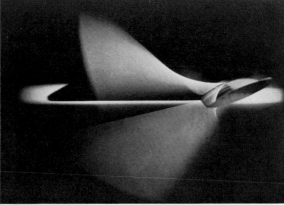

a

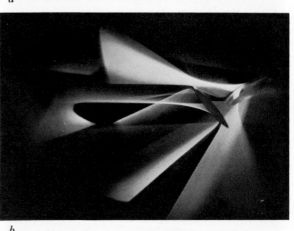

b

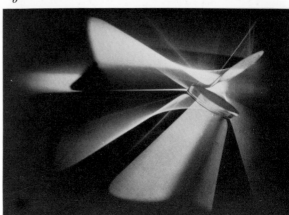

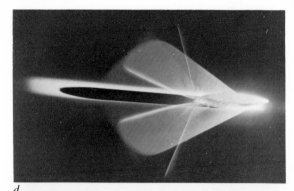

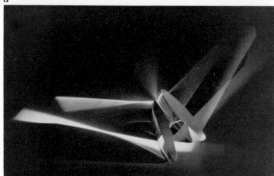

143 a and b Compositions using prisms

143 b

When a parallel beam of light falls on to a concave cylindrical mirror the beam is reflected and concentrated towards the focus of the mirror. As rays from the outer parts of the mirror converge at a point nearer to the mirror than rays from the inner part, a bright curved line, the caustic curve is formed *(144)*. If the mirror is swept by a wide beam or by several

parallel rays of light the caustic curve swings rapidly across the field *(144 a-d)*.

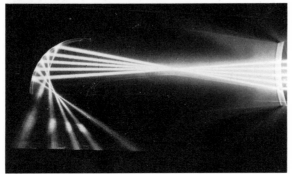

144 a Caustic curve

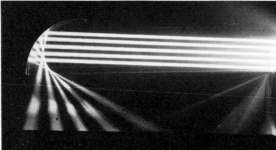

144 b, c and d Caustic curve in movement

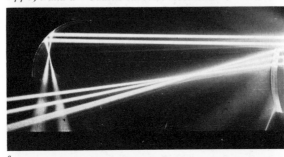

c

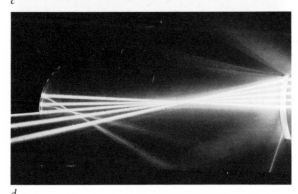

d

The rays may be made to scan the mirror by using either a cylindrical (can) shutter or a disc shutter. The latter is simply the rotor of the rotor/stator system, though timing can be varied by having slots of different widths with different intervals between them, and a longer cycling period is obtained by passing the beam through two successive shutters rotating at different speeds *(145 a, b)*. The can shutter, as its name implies, is a slotted cylinder which encloses the bulb, and is driven by a synchronous motor *(146)*.

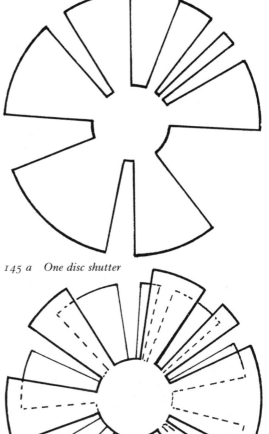

145 a One disc shutter

145 b Two disc shutters

c

146 Can shutter

Prisms can be used either for dispersing light into its component colours or for altering the directions of rays by reflection or refraction (see *chapter 4 (d)*). These properties may be exploited by rotating a prism in a multiple beam of light and picking up the reflected or refracted rays in lenses or mirrors surrounding the central rotating prism *(147)*.

c

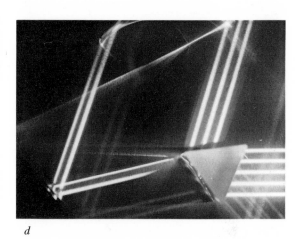

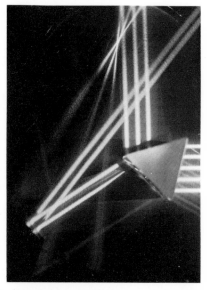

147 a–g Prism rotated in multiple beam

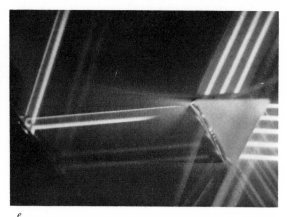
d

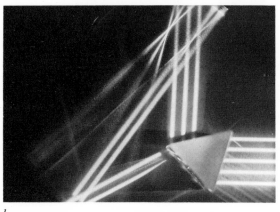
b

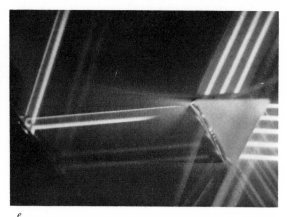
e

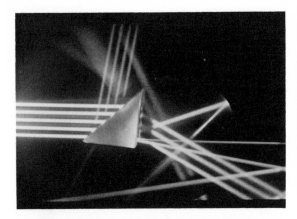

f

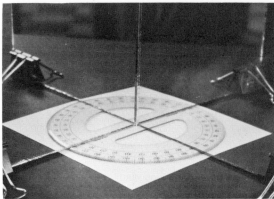

148 *Inclined mirrors*
 (a) 90°

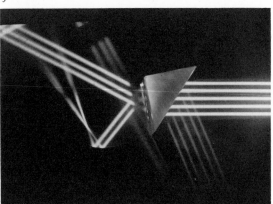

g

Ray-track displays can often be enhanced by using the kaleidoscope technique of reflections in mutually inclined mirrors to produce multiple images. Instead of looking down the line of intersection of the two mirrors, as in the kaleidoscope, the spectator looks into the two mirrors which are arranged symmetrically about the line of vision of the spectator, and behind the display *(148)*. Angles of 90° and 60° between the mirrors give fourfold (a) and sixfold (b) symmetry respectively, and the display will, under these circumstances be symmetrical. An angle of 72° will give fivefold symmetry, (c) which in many ways is less static than four or sixfold symmetry, but needs a symmetrical display to produce the best effect, and 120° will give a threefold symmetry (d) which can appear even less balanced than the fivefold. Sixfold symmetry is the smallest that will produce a completely symmetrical display under all circumstances.

(b) 60°

(c) 72°

(d) 120°

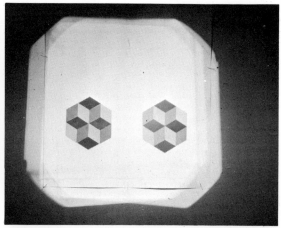

(d) Light and pigments

Displays involving coloured light and pigment together are often the most spectacular of all. A change in the colour of the illuminating light can cause a complete tonal reversal in many cases, or a change from an extreme tone to a mid-grey. Illustrations *a–e* on *colour plate 4* show a pattern of interlaced red and green strips and yellow squares under white light, the three primaries red, green and blue and the complementary yellow formed by red and green. Under different colours the emphasis changes from checks to horizontal or vertical lines, or grouped patterns. In diagram *149* the hexagonal design of the rhomboids (a) becomes three cubes seen from above (b), or three cubes seen from below (c). The reverse effect can be produced by painting the faces of cubes in different colours, the correct lighting reducing the three dimensional form to a two dimensional pattern.

149 a, b and c Effect of coloured light on pigment. Hexagonal pattern

(e) Polarised light

Light waves vibrate transversely across the direction of the ray, like the waves produced in a rope when one end is moved rapidly up and down. The light from a normal source vibrates in all directions, as if the rope were being shaken vertically, horizontally and diagonally, all at once. Under certain conditions all the movements except those in one plane only can be eliminated from the ray, and the light is then plane polarised or simply polarised.

Polarisation can be caused by simple reflection, by passing the light through a prism constructed from one of a particular group of minerals, or by using a synthetic filter of *Polaroid* sheet. At a certain well-defined angle of incidence ($57°$ from the vertical) reflected light is almost completely plane polarised, and light reflected at other angles is partially polarised, the degree of polarisation falling off either side of the angle of $57°$. *Polaroid* sheet stops all the vibrations except for those in one plane only, and the efficiency of *Polaroid* sunglasses depends on the fact that the polaroid is so orientated in the spectacle frames that it absorbs the rays that are reflected directly from the surface ahead (such as the road when driving towards the sun), and transmits only the rays that are not directly reflected. This can be demonstrated by turning *Polaroid* sunglasses until the frames are vertical, and in this position the glare from reflected light is almost as intense as it would be without the glasses. The effect may best be visualised by imagining a rope passed through a vertical slot in a fence, and then through a horizontal slot in a gate. If the rope is shaken vertically the waves will penetrate the fence, but fail to penetrate the gate. If it is shaken horizontally it will not even pass the fence. Therefore if two pieces of polaroid sheet are held so that they polarise the light in the same plane the light will be transmitted, but if they are 'crossed' the light passing the first will be stopped by the second.

Certain substances, among them cellophane, are bi-refringent, that is they have the property of transmitting light at different velocities in different directions. For reasons too complex to be dealt with here, if a sheet of cellophane is crumpled and placed between two crossed sheets of polaroid, or if strips of transparent adhesive tape are stuck on to an acrylic sheet and placed between crossed polaroids, some light passes through the second sheet. Because light of some wavelengths emerging from the cellophane by different paths is 'out of phase', the waves cancel each other out, and no light of that particular wavelength is transmitted, removing that particular colour from the white light. Light of other wavelengths emerges 'in phase' and is therefore able to penetrate the second sheet of polaroid, giving rise to the sensation of the corresponding colour. The colours change as the cellophane or the polaroid is moved, and give some very beautiful and subtle effects (see *Polaroid circles, colour plate 4,* facing page 113).

Part III

7 Control of light: mechanical

A beam of light may be controlled in two ways, by altering the light source with dimmers or switches, or by interrupting the beam after it leaves the projector, the light source itself remaining constant. For convenience the present chapter deals with altering the beam mechanically from a constant source, and subsequent chapters with dimming and switching, both electrically and electronically. The divisions are arbitrary, and necessarily overlap to some extent, but they form convenient starting points.

(a) Shutter

The simplest form of control is the shutter. Used rapidly this is quite adequate as an on-off switch, but a slow movement allows the shadow edge of the shutter to be visible as it crosses the field. A shutter sliding sideways with a stop to limit the range of movement can be operated quite rapidly enough to make a clean switch-over *(150)*, (see Appendix page 133 for details of construction). A rotating shutter is equally effective, and may have its axis at right angles to the beam *(151a)*, or parallel to it *(151b)*. The shutter with the transverse spindle can be remotely controlled from behind the projector, and both the rotating shutter with the axial spindle and the sliding shutter can be controlled from the side.

To control intensity the light can be masked off by a shutter with a series of holes of different sizes. Some form of gate similar to a motorcycle gear lever gate is necessary for the operating

150 Sliding shutter

151 a Rotary shutter, axial spindle

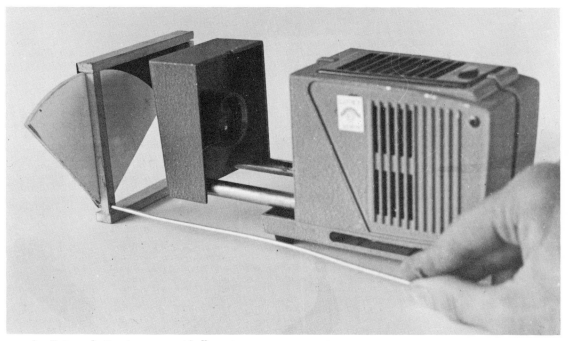

151 b Rotary shutter, transverse spindle

lever to provide the positive positioning of the shutter *(152)*.

A variable shutter can be made from two fishtail shutters working in opposite directions *(153)*, (a modification of the rotor-stator system, see section c). A loop of cord tacked to the shutters and run over two curtain track pulleys gives the contrary motion. The unit is operated by pulling the cord or sliding one half only.

If the long shutter of diagram *152* is made of acrylic sheet and filters applied, it forms a colour change unit. Cinemoid filters of professional standard are the best to use, and a cellulose tape provides a good temporary fixing, or acrylic sheet cement a permanent fixing. Coloured tissue paper glued on with dabs of paste at the corners makes an effective and cheap substitute for limited use.

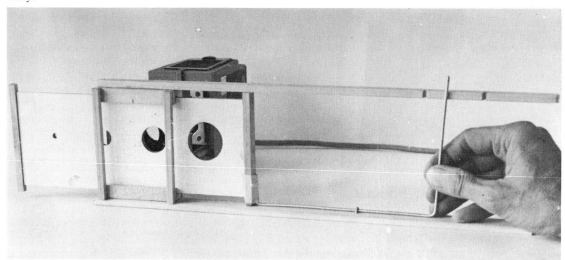

152 Multi-hole shutter

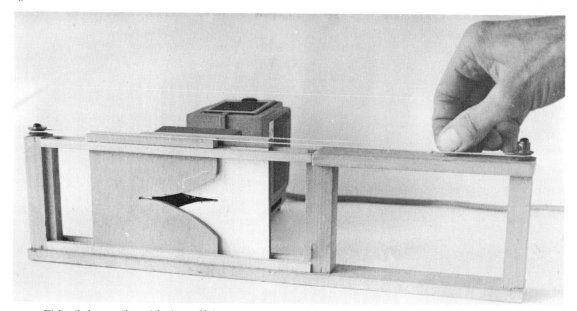

153 Fishtail shutter (logarithmic profile)

(b) Rotating disc

A very effective way of controlling light in both colour and intensity is by a rotating disc driven by a small motor. Synchronous motors are available in a range of speeds from 6 rev/min to 6 rev/hour, use little current, and are quite powerful enough.

The simplest disc is made of segments of cinemoid sheet stuck temporarily to an acrylic sheet disc with cellulose tape (see Appendix page 133 for constructional details). Though not as permanent as a segmented disc of coloured acrylic sheet cemented together, it is cheaper, and the colours can be changed quickly.

The obvious colour change is simple segments *(154)*. The colours sweep across the field with a radial division, rotary motion, and change is abrupt. When cross fading between colours is needed the filters are overlapped at the changes *(155)*. The double layer is of course darker than the single, but if weaker filters are used, the overlap is not too dark, and the main area of each colour is built up of two or three layers to balance the intensity of the different segments *(156)*.

156 *Segmented disc, with overlap, detail of construction*

A radial movement of the colour boundary provides a change from the pure rotary movement, and may be mixed with it on the same disc. A curved profile to the filter is needed (see (c), The Rotor/stator system), and to keep the colour edge reasonably at right angles to the radius of the disc, a fairly large segment is required, unless the projector lens is fairly small in relation to the disc *(157)*.

157 *Radial movement of colour edge*

A steady alternation of two colours is given by a wave-like join running round the disc *(158)*, and a continuous upwards (or downwards) movement results from spiral joins *(159)*.

154 *Segmented disc*

155 *Segmented disc, with overlap*

158 *Continuously reciprocating radial alternation*
159 *Continous unidirectional radial alternation*

91

Fish-tail joints *(160)*, give continuously expanding (or contracting) colours, the point introducing the new colour in the centre of the field.

160 Continuously expanding (or contracting) fishtail

Changes of intensity of white or monochromatic light is easily provided by applying successive layers of very thin tissue paper to the acrylic sheet disc, building up a step-wedge *(161)*, and for an automatic on-off sequence thin card is used instead of paper *(162)*.

161 Step-wedge disc

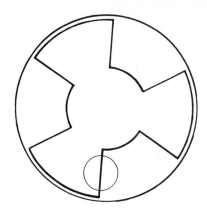

162 Segmented disc

(c) The rotor-stator system

This is the basic system from which the previous examples have been derived. The rotor is an opaque disc with holes or slots cut in it, and again acrylic sheet and black paper masks can be used. Discs can be made of strawboard or hardboard, or even sheet aluminium, but they are more difficult to work, and in the case of the two boards, the edges are never very clear-cut. The stator is a stationary member of similar construction, and the light passing through the holes in the disc is masked selectively by the stator *(163)*, (a) front elevation, (b) side elevation. The front of the stator is concealed by a translucent screen (acrylic sheet, opal 050, or tracing paper stretched in a frame). If this screen is near to the stator the edges of the areas of light are sharp, and if the screen is a few centimetres away they are softer. The screen, stator, rotor and light source or sources are totally enclosed in a box, of which the screen forms the front *(164)*. Ventilation is necessary in the back of the box to permit the dissipation of the heat generated by the lamps.

(a) front elevation *(b) side elevation*

163 Rotor/stator system

164 Rotor/stator back-projection unit, cross section

165 b Rotor/stator system, two overlapping rotors, end elevation, similarly rotating discs

The rotors are driven conveniently by synchronous motors, old tape recorder or record player motors, *Meccano* motors, etc, or via some form of gearing or belt drive (see page 94) from an old washing machine or suction cleaner motor. If several rotors need to be driven simultaneously, the simplest method is to run an endless band round all the pulleys and the drive, different speeds being obtained from different sized pulleys. The most effective way is *Meccano* chain and sprockets, but belts can be devised from square-section model aeroplane rubber or expanding curtain taut rod running over turned wooden pulleys *(165a)*, and appendix. Diagram *165* shows two discs partially overlapping in side elevation, (b) and (c) are rear elevation, (b) with both pulleys rotating in the same direction, (c) with the pulleys rotating in opposite directions, an idler taking the belt or chain down to give a sufficiently large arc of contact to the lower driving pulley or sprocket.

165 c Rotor/stator system, two overlapping rotors, end elevation, contra-rotating discs

The fixing boss in the centre of the rotor is occasionally a nuisance, but a clear centre is possible if the rotor is mounted as in *166*. The pulleys are built up from centre-bored dowelling or slices of cotton reel, with flanges of 3 mm plywood glued and pinned to the ends. A friction drive is used to turn the disc. A small piece of rubber tube is put on to the driving pulley before the second flange is glued on, or

165 a Rotor/stator system, two overlapping rotors, cross section

166 Rotor with clear centre

a sleeve placed on a spindle of a small electric motor positioned so that the spindle bears on the edge of the disc, thus providing the necessary reduction gear at the same time. A change of gear ratio is provided by using a centre-drilled rubber bung (such as those used for scientific apparatus) instead of the rubber tube on the motor spindle, or a speed control from an electric drill used if the motor is a commutator motor. If the motor is housed in a frame pivoted on the rotor side of the çentre of gravity of the motor, the weight of the motor holds the spindle against the rotor, and saves having to use springs or weights *(167)*.

167 Motor in housing bearing on the edge of disc (friction drive)

Two rotors, one a colour disc, can be mounted concentrically on the same spindle by using the clock-hand type of mechanism *(168)*. The outer rotor is mounted on the solid rod spindle as usual, and the inner rotor is mounted on a tube through which the rod passes. At the rear of the unit the tube and the rod have pulleys fastened similarly at the ends. The tube has a threaded flange to which the inner rotor and pulley are screwed, and the outer rotor and pulley are lock-nutted to the rod as usual (see Appendix). Drive is from a double pulley on the rotor spindle, with one endless belt *(169)*.

168 Concentric spindle mechanism

169 Endless belt drive for two rotors

The movement of the areas of light on the screen are determined by the shapes of the holes or slots in the rotor and stator. The principle is similar to that of Crova's disc, used to demonstrate the passage of compression waves, (eg, sound waves). If a spiral is rotated behind a fixed slot, the effects observed is of lines moving outwards *(170 a, b* and *c)* show successive positions of the lines. When the spiral is replaced by a spiral slot in a black paper disc glued to an acrylic sheet disc, the spots of light move outwards along the straight slot in front of the disc. A large spot moving outwards is plotted in detail in diagram *171*. The spot must, in this case, advance radially an equal amount for equal angles of rotation. The basic spiral is plotted first, the angles being marked anti-clockwise from the centre if the disc is rotating clockwise. Concentric circles are drawn at equal intervals, crossing the radii, and successive crossing points are joined with a smooth curve.

A continuous in and out oscillation, like the colour change in diagram *158* results from a continuous inward and outward curve. Two curves may be placed on the same disc so that the lights move towards and away from each other *(172)*. The stator may equally well have two slots, or a Y shaped slot, so that two or three lights can move simultaneously.

If a movement is required to pass beyond the centre of the disc, the disc is replaced by a drum *(173)*. Two slots from top to bottom of the drum will give a steady movement of the light for the whole distance. The effect in this case can be doubled by adding a second light source behind the drum *(174)*.

*170 a, b and c Three successive positions in spiral
movement behind a slot*

*171 a, b and c Radial movement of spot with spiral
rotor slot*

172 Two spots in continuous contrary movement *173 Drum rotor*

174 Drum rotor with two light sources (plan)

Plate 3

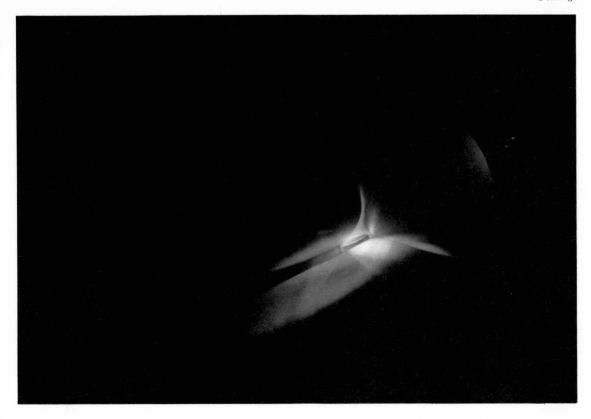

*Coloured light projected through a cylindrical convex
lens*

8 Control of light: electro-mechanical

This chapter deals with various methods of switching the light on and off, and with dimming with rheostats or resistances. It includes remote control relay switching and mechanical operation, but the actuation of relays by a light-sensitive circuit or by sound, etc, is left to further chapters.

(a) Relay switching
(i) Iron-cored relays

An iron cored relay consists of a coil of wire round a soft iron core which forms an electro-magnet when a current is passed through the coil, and a movable contact which is pulled in by the magnet. *175a* is a photograph of a typical ex-equipment relay and (b) a photograph of a miniature relay. *176* is an enlarged diagram of the three types of contact, designated by the state of the switch when the relay is not energised. (a) is normally open (n/o), (b) is normally closed (n/c). and (c) is change-over (c/o). (c)(i) is break-before-make (B-M) or non-shorting, when there is a definite break during the change-over and (c)(ii) is make-before-break (M-B) or shorting, which means that at the change-over two circuits are alive simultaneously and the surge of current must be allowed for. The ex-equipment relay in the photograph has two sets of change-over contacts on one side (break-before-make), and three sets of on-off contacts on the other, one normally closed and two normally open. The miniature plug-in relay has two sets of change-over contacts. Relays are classified by the operating voltage and resistance, and by the voltage and current that the contacts can carry. This is normally the maximum amount of current that can be safely made or broken without undue arcing at the contacts. Cold electric lamps have a low resistance, and there is a surge of current until the resistance rises as the filament heats up. The maximum current that can be made or broken is therefore less than the contacts would carry under steady load

conditions. This of course applies to all forms of switch contacts, and not only to relays.

175 Iron-cored relays :
 (a) ex-equipment

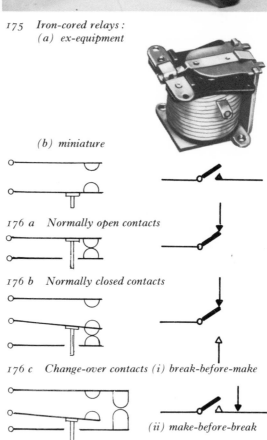

 (b) miniature

176 a Normally open contacts

176 b Normally closed contacts

176 c Change-over contacts (i) break-before-make

 (ii) make-before-break

(ii) Dry reed relays

Dry reed relays or reed switches are miniature, fast-acting relays; *177a (i)* is a cross section of a typical reed switch. The two contacts are enclosed in an evacuated glass envelope *a (ii)*, and the leads are brought out at the ends. The contacts are plated with a non-corroding metal, such as gold or palladium, and as they are in a near vacuum are free from dust, damp, etc. A coil (b) is placed round the envelope, and when a current is passed through the coil the magnetic field moves the contacts. A small permanent magnet may also be used to operate the switch or bias it normally closed. Because of mechanical simplicity and the freedom from contamination, dry-reed relays are much more reliable than the iron-cored relays for many applications. Their main disadvantage is that at the present stage of development they will carry only small currents.

177 a Dry reed relay
(i) Cross section of typical reed switch

(ii) Glass envelope in which the two contacts are enclosed

177 b Operating coil

(b) Rotary drum switching
(i) Drum switch

A rotating drum is used when a cycle of lights has to repeat itself, eg, traffic lights. There are two basic forms, one having contacts on the drum, and the other having projections which activate switches. A drum can be made by applying strips of thin copper or brass foil (0·1 mm or 0·004 in) or aluminium to a wooden roller, or a strong cardboard tube plugged at the ends *(178a)*, or by cutting an insulating mask of thin flexible plastic sheet (PVC) and applying to it a metal tube or circular tin can (c). Contact strips made of hard brass (or terminal strips of exhausted flat two or three cell torch batteries) bear on the strips on the drum, and as the latter rotates the current flows whilst there is metal-to-metal contact, but stops when the contact strip rides on to the insulated portion of its track. With a set speed of rotation the number of makes and breaks and the durations can be planned quite accurately. If the feed to all the circuits is the same, a slip ring at the end of the drum will pick up the current from the input contact (C in), and a wire to all the strips on the insulated drum (a) will supply complete the circuits to the output contacts (C out). The metal drum will of course be live itself. A spindle may be soldered to each end of the metal drum, or two wooden plugs the diameter of the drum may be pressed in the ends to carry the spindle. If the circuits are to be separate each needs its own slip ring (C in), and contact strip (C out) on an insulated (wooden) drum (b).

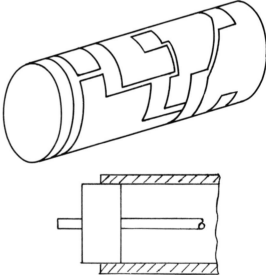

178 Drum switches
(a) Insulated (axonometric and cross-section)

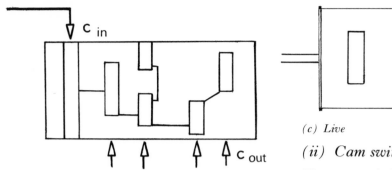

(c) Live

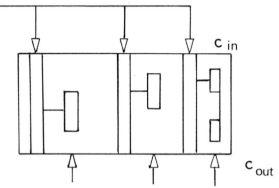

(continued) Insulated (side elevation)

(b) Insulated (separate circuits)

(ii) Cam switch

The cam switch consists of a series of cams, each actuating a micro switch. *179* (a) and (b) are professional switches of this type. Equivalents (c) can be made from two inch dowelling with galvanised iron wire cam lobes driven into the wood (c i), or strips of strawboard glued and pinned to a cardboard tube (c ii).

When two contacts carrying a current are separated the current will continue to flow across the gap until either the gap increases until it is too large for the arc to be maintained, or the voltage drops until it cannot maintain the current across the existing gap. A direct current (d.c.) which flows steadily in the same direction would therefore need breaking by increasing the gap, and the faster the contacts were separated the less arcing would occur.

179 Cam switches (a) Actan

(b) Sealectro

(c) (i) wooden

(ii) cardboard

An alternating current (a.c.), on the other hand, rises from zero to a positive peak, falls through zero to a negative peak, and rises to zero again to complete the cycle. The arc caused by interrupting the current is therefore self-extinguishing, as it cannot be maintained beyond 0 volts, and a slow small break would keep the spark to a minimum.

(c) Micro switches

The micro (micro-gap) switch is designed to handle a.c. only, and is totally unsuitable for d.c. use, except at low voltages. A switch rated at 5 amps, 240 volts a.c. may be rated at no more than 0.5 A, 12 V, d.c. Because of the small movement required to separate the contacts the switch needs only a small light movement to operate it. Various types of lever are available, press button, roller arm, etc *(180)*.

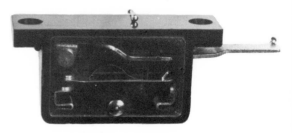

180 Micro switches (a) open

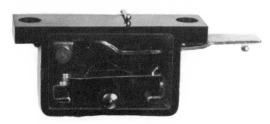

(b) closed

(d) Mercury switches

A mercury switch consists of a glass envelope with contacts sealed into the glass and a small pool of mercury which, when the switch is tilted, runs along the inside envelope and makes or breaks the contacts. *(181)*. This switch is useful when a mechanical movement has to cause an electrical effect, such as switching on a light when a loose floor panel is tilted by stepping on to it.

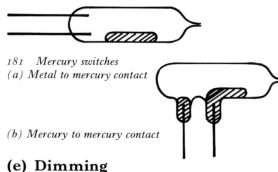

181 Mercury switches
(a) Metal to mercury contact

(b) Mercury to mercury contact

(e) Dimming

Any conductor has a certain amount of resistance to the passage of an electric current, which causes a slight voltage drop between the ends of the conductor. If cable of the correct diameter is used the voltage drop in normal use is negligible.

Certain substances will pass some current, but as the electrons in them are more tightly bound to the nucleii of the atoms than those of good conductors, more power is used overcoming the resistance of the electrons to being moved. If a component made of one of these resisting substances is included in a circuit, there will be an appreciable voltage drop across it, and less power will be available for the load. Such a component is called a resistor (formerly a resistance). (See *chapter 9, Components*).

A resistor may be variable, in which case the voltage applied to the load is gradually reduced, or a number of resistors can be switched in, in series, so that the voltage is changed in several distinct steps. A rotary drum with cams holding the switches on for a given period is the simplest form of electro-mechanical dimmer (see *179*). The wiring diagram for a six-step dimmer is given in *182*. When all the switches are open all the resistors are in circuit, and as the switches from 1 to 6 close in sequence, the resistors are cut out from R 1 onwards. Switch S 6 cuts out the whole chain. Typical values of resistors are given to drop a 150-watt lamp to the lowest practical level. Light values have to increase logarithmically to create the visual impression of equal steps, and a satisfactory low level is obtained when the total resistance in series with the lamp approximates to the resistance of the lamp itself. *(183)* gives the cam settings for a 6-gang rotary cam switch set to give equal times cycling down and up. Change-over switches are used so that by taking the common terminal and only one of

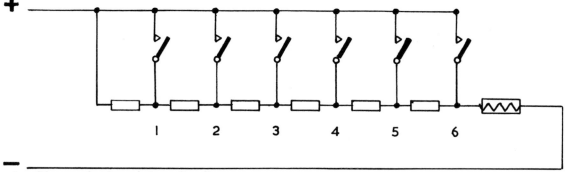

182 Diagram of resistor-chain, cycling dimmer

the other two terminals the switches can be treated as normally open or normally closed as indicated.

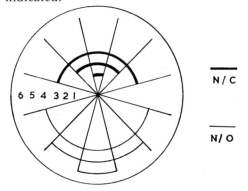

N/C

N/O

183 Cam settings for 182 to give even stepping forfading down and up

When a lamp needs permanent dimming, such as an indicator lamp which is too bright on a switchboard, a resistor in series with the lamp will drop some of the voltage and reduce the brightness of the lamp. A series resistor is also used to drop a voltage permanently to a lower level, eg, to run a neon indicator on a mains supply, or a 6-volt car radio from a 12-volt supply. Assuming that a typical 6-volt bulb draws 0.1 A, and is to be run from a 15-volt supply, a series resistor will have to drop 9 V at 0.1 A. The value is calculated from the

formula: $R = \dfrac{V}{I}$, (see chapter 11, section (b)).

ie $R = \dfrac{9}{0.1} = 90 \ \Omega$

The resistor will have to be able to dissipate the power without overheating, and the power rating is calculated from the formula:

$$P = VI$$
ie $P = 9 \times 0.1 = 0.9$ W

or $P = I^2 R = (0.1)^2 \times 90 = 0.01 \times 90$
 $= 0.9$ W.

Therefore a 90 ohm 1 watt resistor would just be sufficient. A cement coated wire wound resistor on a ceramic former running near its limit could easily reach a body surface temperature of 250° to 300° C, and provision must be made to keep it away from components liable to be damaged, and to dissipate heat.

As the resistance of a tungsten filament lamp varies non-linearly with temperature, there is no simple way of calculating the values of the resistors. The following table gives the corrected experimental results for a 250 volt 150 watt pearl lamp run at 240 volts.

V_L voltage across the lamp
V_R voltage across the resistor
L light output (lumens)
I current (amps)
R_E external resistance
R_{1-6} individual resistors of chain
 (1 and 2, one amp rating, 3 to 6, half amp rating).

	V_L	V_R	I	R_E	R_{1-6}	L
1	240	0	0·570	0	0	1700
2	214	26	0.535	48	48(1)	1065
3	189	51	0.503	102	52(2)	660
4	166	74	0.473	156	54(3)	412
5	146	94	0.445	210	54(4)	256
6	130	110	0.420	260	50(5)	160
7	120	120	0.400	300	40(6)	100

9 Control of light: electronic

Simple electronic circuits which react to light, sound, or touch, or to small signal currents from the output of a tape-recorder, etc. can easily be used to control relays or reed switches, or to control thyristors (silicon controlled rectifiers). With thyristors in particular, loads of up to 2 kilowatts can be switched by signals of the order of 150 milliwatts. Thyristors are used for dimming as well as switching, the thyristor units having a number of advantages over the conventional rheostats or resistances.

(a) Semiconductor devices

Semiconductor devices are used in these circuits as they have several advantages over the thermionic valves which could also be used. A semiconductor requires much less power to drive it than a valve performing an equivalent function. There is usually a negligible amount of heat generated, and this can be dissipated quite easily by a metallic heat sink in mechanical contact with the semiconductor if it is necessary. Semiconductors are usually quite small, and units can easily be built up on a perforated laminated board (synthetic resin bonded paper) with copper strips on the underside (eg, *Veroboard*), and will occupy little space. The valve requires a supply for the cathode heater filament, which necessitates a mains transformer or a comparatively large battery; but the semiconductor needs only a small voltage bias, which is in no way comparable. The semiconductor device is made of crystals of either germanium or silicon which have first been purified to better than one part in ten thousand million, and have then had precisely controlled quantities of impurities added to them in the proportion of about one part per ten to a hundred million. The crystal in its pure state is a poor conductor, as the atoms are bound together in a stable lattice, in which each atom has four electrons (valency electrons) in its outer shell, forming bonds with similar electrons of the four neighbouring

atoms. Diagram *184* shows a two dimensional form, and *185* a three dimensional representation of a single atom, (a body-centred cube with the electrons at the vertices of the inscribed tetrahedron). The impurities are elements of a similar group, but with three or five valency electrons instead of four.

184 Crystal lattice

185 Tetrahedral structure in a cube

If arsenic (or antimony) with five valency electrons is added to germanium (or silicon), there will be some electrons loosely held by the nuclei of their respective atoms *(186)*. These extra electrons are free to wander through the crystal lattice, and though the whole crystal is still electrically neutral, it is called N (negative) type, as it has some freely moving negatively

103

charged electrons. Arsenic is called a donor impurity as it donates the mobile electrons.

186 Donor atoms

If indium (or aluminium) with only three valency electrons is added to the crystal of germanium (or silicon), the whole crystal, though still electrically neutral, now has a number of empty spaces in the lattice, diagram *187*. Electrons keep on moving from hole to hole, and this has the same effect as holes moving in the opposite direction. If an electron moves to a hole on its right the hole 'moves' to the atom on its left. As a negatively charged electron will combine with a hole, the holes are considered to be positively charged. Indium is called an acceptor impurity, as the vacant space enables it to accept electrons from the neighbouring atoms to complete the stable four-electron structure. When two pieces of

187 Acceptor atoms

104

crystal, one P-type and one N-type are joined together to form a pn junction, negatively charged electrons from the N side cross to recombine with spare positively charged holes on the P side of the junction, and leave behind donor atoms which are now electrically positive as they are an electron short. At the same time positively charged holes from the P side cross to the N side of the junction and leave behind acceptor atoms which are electrically negative. The area of the crystal round the junction in this way develops a charge which inhibits further movement of the electrons and holes *(188)*.

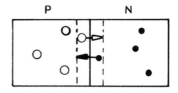

188 P N junction

(b) Junction diode

If a battery is connected to the crystal with the positive terminal to the P side, and negative to the N side, the electrical pressure forces extra electrons into the N side, and extra holes into the P side of the crystal *(189)*. The junction is now said to be forward biased, and conducts freely.

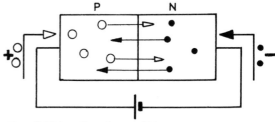

189 P N junction : forward bias

When the battery polarities are reversed, diagram *190*, the negative electrons are pulled away from the junction to the positive terminal of the battery, and the positive holes towards the negative terminal of the battery. No further drift of electrons or holes can now take place, and the current ceases to flow. This condition is called reverse bias.

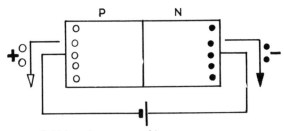

190 P N junction : reverse bias

The junction diode works in this way, and is used as a one-way 'valve', permitting current to flow only when it is forward biased. The rectifier circuits (*chapter XII*, section (b)), employ semiconductor diodes for this purpose.

(c) Transistor

A three-layer device has a very thin section of crystal of one type (the base), between two larger sections of the opposite type *(191)*. If the first junction has a forward bias the current will flow easily through the first junction, and if the second PN junction has a reverse bias no current will flow. Under certain conditions of 'doping' (adding impurities), the holes emitted into the forward-biased P section cross through the base, and are collected by the second P section, having broken through the reverse biased PN junction. A small increase in the emitter-base current will cause a large increase in the base-collector current, and amplification of power is obtained. This device is the transistor, the word being coined from *trans*fer res*istor*, as the effect of altering the resistance

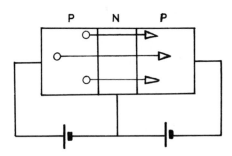

191 P N P (three layer) device

of the first PN junction (by controlling the amount of current through it) is to alter the resistance of the second PN junction by a greater amount. (NB the foregoing brief description of the working of semiconductors, while sufficient for the present purpose, is not entirely correct. If a more accurate and detailed knowledge is required, see bibliography).

Transistors can be PNP or NPN, the latter being more difficult to manufacture and therefore less common. Silicon NPN transistors are now replacing the (germanium) PNP transistors. Silicon semiconductors will withstand higher working voltages and currents than germanium, but are more expensive to produce.

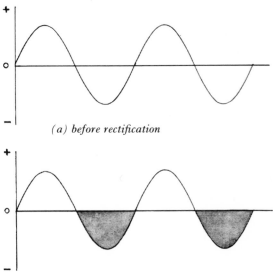

(a) before rectification

(b) after rectification. (Tinted areas show non-conductive periods)

192 Graph of an alternating current,

(d) Thyristor

The thyristor *(thyra*ton trans*istor)* is a silicon rectifier, ie, it will pass a current in the forward direction and block the reverse current. Diagram *192* is a graph of an alternating current, (a) before and (b) after a rectifying device. The thyristor is composed of four layers of alternate P and N type silicon, and in its normal state will block a current from either direction. A third electrode, known as a gate, is connected to one of the inner layers, and if a small pulse is applied

to the gate for a few micro-seconds the thyristor 'breaks down', and becomes fully conducting in the forward direction. Removal of the gate pulse will now have no effect, the thyristor will continue to conduct until it becomes reverse-biased or the forward voltage drops below a certain minimum level. If the gate pulse is applied at the commencement of a positive half cycle the thyristor will conduct for the duration of the half cycle *(193)*, and resume its non-conducting state during the negative half cycle. If the commencement of the pulse is delayed until half way through the half cycle *(194a)*, or until near the end of it *(194b)*, conduction occurs for a shorter time per half cycle, and less power is applied to the load. In this way the thyristor is used for dimming lamps or for speed control of electric drills, etc.

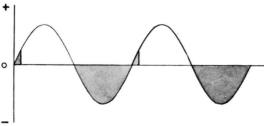

193 Graph of forward current through a thyristor with the triggering pulse applied to the gate at the commencement of the positive half cycle

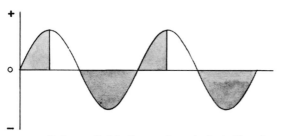

194 a Pulse applied half way through the half cycle

194 b Pulse applied at the end of the half cycle

(e) Passive components

(i) Resistor

A resistor is a component which offers resistance to the passage of an electric current. It may be a high-resistance wire, carbon, tin oxide, etc, and may be of a fixed value, an adjustable value which is set on testing (pre-set), or a variable value which may be altered to suit changing conditions (volume control, frequency control, etc). There are two main uses of resistors. One is to control current or voltage, and the other is to develop a voltage or current. If two (or more) resistors are connected in series across a source of voltage, the voltage will be divided in proportion to the resistances (see *chapter 11*, section (b)). A resistor in series with the load will limit the current in the circuit, the value of the resistor being calculated from the applied voltage and the current required. When a current of a fixed value is flowing in a circuit it will develop a voltage drop across a series resistor in the circuit.

(ii) Capacitor

A capacitor in its simplest form consists of two metal plates a short distance apart. When a voltage is applied to the two plates a current flows immediately, a positive charge (lack of electrons) builds up on one side of the capacitor, and a negative charge (excess electrons) on the other, with an electric field between the plates *(195a)*. Once the voltage across the plates of the capacitor equals the battery voltage the current ceases to flow. When the switch is opened the charge remains on the capacitor and the electric field is still present. On closing the switch in the alternative position *(195b)*, the excess electrons flow round the circuit to the positively charged plate, and the field collapses. A capacitor stores electrical energy in a similar way to that in which a spring stores mechanical energy. As long as the voltage is maintained the capacitor remains charged. As soon as the voltage is removed and a discharge path completed the energy in the capacitor returns to the circuit.

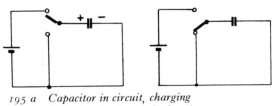

195 a *Capacitor in circuit, charging*
195 b *Capacitor in circuit, discharging*

(iii) Inductor (coil)

When a current flows through a wire it creates a magnetic field round the wire. If a second wire is laid alongside the first a current will be induced in it if the loop path is completed. This induced current in turn produces a voltage in the first wire, but in the opposite sense, the induced voltage opposing the original voltage *(196)*. If the first conductor is wound into a coil each turn of the coil acts as if it were the second loop in diagram *196*, and will oppose the voltage in the previous turn as long as the voltage is increasing or decreasing in magnitude. A direct (steady) current will flow unopposed.

196 *Inductance*

(iv) Circuit with capacitance and inductance

When a direct current is passed through a circuit with a capacitor, the current flows until the charge builds up on the capacitor and then ceases. The capacitor therefore blocks a direct current. An alternating current with low frequency will alternately charge, discharge and recharge the capacitor in the reverse direction, with a pause in the fully charged position. As the frequency increases the pause diminishes, until the capacitor does not quite have time to charge fully on each cycle, and at this stage the capacitor creates the effect of passing the alternating current unhindered.

a High

b Low

197 *Action of a capacitor compared with a diaphragm*

The effect is similar to that of a flexible diaphragm in a water pipe *(197)*. When pressure is from the left the diaphragm bends to the right, and increases the pressure on the far side *(197a)*. When the pressure is reversed the diaphragm bends to the left and reduces the pressure on the far side *(197 b)*. Although no water actually flows past the diaphragm high and low pressure pulses are transferred to the side further from the source of the pulses. In a similar way the effect of an alternating current is transferred to the far side of a capacitor without actually flowing through it, the magnetic field between the plates of the capacitor taking the place of the diaphragm in the water pipe.

The opposite occurs when a current flows through an inductor. A direct current (zero frequency) will flow unhindered, but an alternating current will develop the opposing voltage, and as the frequency increases the impedance of the inductor to the flow of current increases.

The properties of capacitors and inductors are used in two ways, to block an a.c. or a d.c. component in a current which is a mixture of both, and to select or reject a current of a particular frequency. Diagram *198* is a transistor amplifier. The base of the transistor is fed with the a.c. signal through the capacitor C_1, which couples this stage to the previous stage, and isolates the d.c. bias for this transistor from the previous one. The capacitor C_2 is a decoupling capacitor, by-passing the a.c. signal round the stabilizing resistor R_3. Resistors R_1 and R_2 form a voltage divider to provide the correct working bias for the

transistor. The transformer provides the load across which the output voltage is developed, and at the same time isolates any d.c. component.

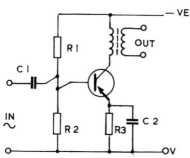

198 Transistor amplifying stage

Capacitance and inductance can be combined to pass or to stop signals of a given frequency. If an inductor and a capacitor are connected in series *(199a)*, the inductor will pass the low frequencies and block the high frequencies, and the capacitor will do the opposite. *199b* shows the impedance of a capacitor C and an inductor L as the frequency rises from zero frequency (d.c.) to a high frequency of a.c. The two different kinds of impedance arise for completely different reasons, and the capacitive impedance is considered negative for currents of low frequency, rising non-linearly towards zero as the frequency increases. The inductive impedance is considered as positive, rising linearly from zero with the increase of frequency. At low frequencies the capacitor impedes the current, which would otherwise be passed by the inductor, and at high frequencies the capacitor would pass the current now impeded by the inductor. As the frequency increases from zero the impedance of the capacitor reduces and the current starts to flow, while the impedance of the inductor begins to rise, but not sufficiently at first to cut off the current. The critical point at which the capacitive and inductive impedances are equal (and opposite) is called the resonant frequency of the circuit, and at this point (x) the current flows unhindered. At frequencies above this the inductor replaces the capacitor as the component which is limiting the flow of current. In a parallel circuit, *(199c)*, at zero frequency (d.c.) the inductor will pass almost the full current, and as the frequency rises the

inductor begins to impede the current, while the capacitor begins to conduct. At the resonant frequency the current flows backwards and forwards within the circuit loop and is almost completely impeded, in contrast to the series circuit in which, at resonance, the current is almost completely passed. Above resonant frequency the circuit begins to conduct again through the capacitor. The resonant frequency is fixed by the relative values of the capacitor and inductor.

199 a Capacitor and inductor—series resonance

199 b Capacitor and inductor—graph of change of impendance with change of frequency

199 c Capacitor and inductor—parallel resonance

A practical application of this principle is the construction of filter networks to divide a complex signal into its component signals and use each component separately. A recorded sound track or a live amplifier output can be used to drive three thyristors controlling three sets of lights in response to sounds of bass, middle and treble frequencies. With more critical circuits a larger number of thyristors could of course be used. *200* shows the two basic forms of high pass and low pass filters,

(tee T and pi Π). The capacitors allow the high frequencies to pass straight through the network in (a), and the inductors shunt the low frequencies to ground. In (b) the inductors pass the low frequencies straight through, and the capacitors shunt the high frequencies to ground. 200 a, b shows the basic stop or trap filters. (a) is the series-tuned trap which shunts the signals of the resonant frequency to earth, and (b) is the parallel-tuned trap which offers a high impedance to signals of the resonant frequency and passes the others.

201 a Series tuned trap b Parallel tuned trap

200 a T and Π (Tee and Pi) high pass filters

200 b T and Π (Tee and Pi) low pass filters

(v) Photocells

There are three main categories of light-sensitive devices, those in which the incident light affects a semiconductor pn junction (photodiode and phototransistor), those in which the light falling on the cells produces a voltage, the light energy being converted into heat (eg, selenium cell), and the photoconductive cells in which the resistance to the passage of an electric current falls in value when the cell is illuminated (eg, cadmium sulphide or CdS cells). The latter are also called light dependant resistors (l.d.r.), and a circuit for a relay controlled by l.d.r. is given in *chapter 10*.

10　Basic circuits

Circuit design is a technical subject and considerable knowledge and experience are necessary to design completely new circuits. This chapter is intended to do no more than explain the functions of the elements and components in the various circuits, and give typical values of the components. If the functions of the various parts of the circuits are known it becomes possible to experiment by adding further stages or units, or modifying circuits to fulfil a variety of different purposes.

(a) Basic transistor amplifier circuits

A transistor is a three terminal device (emitter, base, collector), and as there are two input and two output leads, one of the three terminals must be common to the input and output. In the previous chapter the base was the common terminal, and the emitter-base current controlled the base-collector current (*202 a, b*). A more usual way of connecting a transistor is to make the emitter common to both input and output (common emitter configuration), and make the emitter-base current control the emitter-collector current (*203 a, b*). The circuit diagram of *203* is given in diagram *204*, with the appropriate batteries for a pnp transistor. To save the complication of having two batteries a voltage divider network is used to supply the lower voltage required for the emitter-base circuit from the same battery which provides the higher voltage for the emitter-collector circuit (*205*). The values of R1 and R2 are calculated to drop the majority of the voltage across R1, and leave only the required working voltage across R2. The major disadvantage with this circuit is that as the temperature of the transistor rises it conducts more freely, which gives rise to a vicious circle of steadily rising temperature with increasing current until the transistor destroys itself (thermal runaway). Resistor R3 in the emitter lead in diagram *206* largely

a Block diagram　　　　*b Symbol*
202　Transistor in common base configuration

a Block diagram　　*b Symbol*
203　Transistor in common emitter configuration

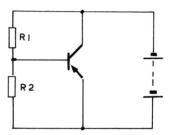

204　Circuit diagram of 203 with batteries

205　Similar circuit to 203, with a voltage divider network replacing the base bias battery

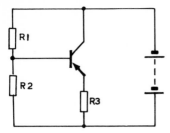

206　*Stabilisation with a resistor in the emitter lead*

prevents this happening, as an increase in current through R3 causes a greater voltage drop across it, and so reduces the base-emitter voltage. This in turn reduces the current flowing and allows the voltage to recover its normal level.

An alternative method of stabilisation is shown in diagram *207*. Resistor R1 supplies the bias for the base of the transistor, and any increase in the collector current lowers the voltage across the load resistor R2. This causes the voltage at the base of the transistor to decrease and allows the collector current to recover its original value.

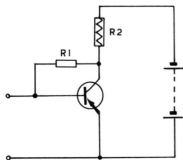

207　*Stabilisation with feedback from collector lead*

A complete amplifier stage is coupled to the previous and following stages by components which will allow the a.c. signal being amplified to pass between the stages, but will isolate each stage as far as the direct (bias) currents are concerned. In diagram *208* capacitors C1 and C3 are isolating capacitors, and C2 is a de-coupling capacitor which by-passes the a.c. signal to earth to prevent the stabilising effect of resistor R3 affecting the signal strength, and hence the total gain of the stage. R1 and R2 form the voltage divider for the base bias of the transistor, and R4 is the load resistor across which the output is developed.

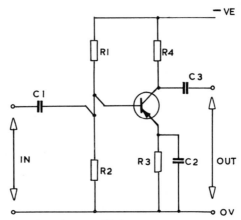

208　*Complete amplifying stage*

(b) Transistor switching circuits

The other main use of a transistor is as an electronic switch *(209)*. When there is no current flowing in the base-emitter circuit, there is none flowing in the collector-emitter circuit, and the transistor is off, ie, the switch is open *(209a)*. *(209b)* is the relay equivalent. When the switch in the base lead is closed the transistor is on *210a*, and the current flows in the main circuit, as in the relay circuit *210b*. The input may often be from a previous circuit sensitive to light or sound, or from a pulse circuit or a logic circuit. The output, amplified or unamplified, may operate a relay, a reed switch or a thyristor to control mains-voltage circuits with loads of up to two or more kilo-watts, or may switch low-voltage loads directly using power transistors for smaller powered displays. The output may also be fed into further circuits to provide sequential switching of a series of lamps or displays.

209 a　*Transistor as a switch, off*

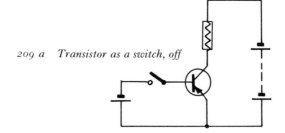

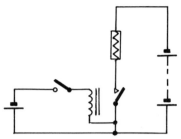

209 b *Relay as a switch, off*

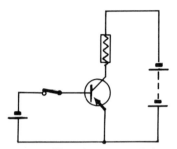

210 a *Transistor as a switch, on*

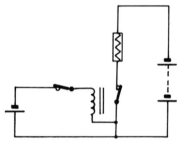

210 b *Relay as a switch, on*

(c) Transistor pulse circuits

The basis of any electrical sequential switching system is the pulse generator, the output from which can be used to drive a ring counter or a multi-stage binary counter. The output from a ring counter is a simple sequence, only one output being live at any time. The binary counter can be used to drive a logic system which will switch combinations of lights on and off, not necessarily one at a time. The final output from the whole combination will be the switching circuits to supply the loads.

One type of pulse circuit has three forms, astable or multivibrator, monostable or flip-flop, and bistable or memory unit. The astable unit will oscillate continuously at a speed

determined by the values of some of the components, the monostable form will stay in one state until it is triggered into the other state by an external pulse, and will recover its first state after a predetermined interval. The bistable unit will stay in one state indefinitely until switched by an external pulse, and will then stay in the second state until a further pulse causes it to revert to the first state.

The three circuits are very similar, the main difference lies in the cross-coupling between the transistors. The circuit in diagram *211* is astable, in *212* is monostable, and *213* is bistable. Capacitive cross-coupling gives astable

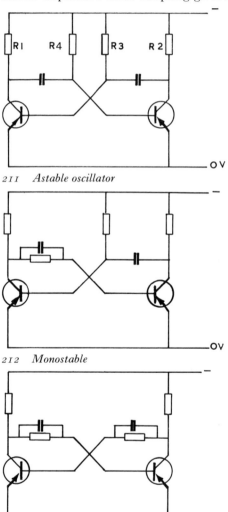

211 *Astable oscillator*

212 *Monostable*

213 *Bistable*

Plate 4

1 Effect of coloured light on pigment ; interlaced strips

(a) white

(d) blue

(b) red

(e) yellow

(c) green

The effects of the red and green light are not truly represented here owing to the difficulty of matching the colour filters and pigments, and the colour sensitivity of the film. The visual effect is as described on page 71

2 Polarised light projected through circles of acrylic sheet on which have been mounted strips of cellophane (see page 86)

operation, resistive cross-coupling bistable operation, and one capacitor and one resistor coupling the monostable operation.

The units are two-stage amplifiers with regenerative feedback from the collector of the second transistor to the base of the first transistor, and if the circuit diagrams are redrawn in this form the working is more obvious (*214 a, b*).

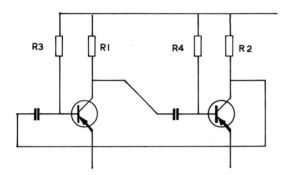

214 a Circuit in diagram 211 redrawn as a two stage amplifier with regenerative feedback

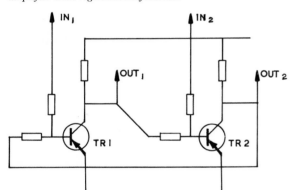

214 b Circuit in diagram 213 redrawn as a two stage amplifier with regenerative feedback

In diagram *214b* the two transistors in the bistable circuit operate as NOR logic units (see next paragraph), with feedback. A negative-going pulse at the base of the first transitor will cause it to conduct, and the voltage at its output to earth (hitherto at the potential of the negative supply) will now rise to almost earth potential. As the output from Tr 1 is the input to Tr 2, the second transistor will not conduct, behaving as an open switch. The voltage at its output will be negative (connected to the negative supply line via the resitor, and with no path to earth through the transistor), and this negative voltage is applied to the base of Tr 1, already negative, thus holding it conducting even when the input pulse which initiated the sequence has been discontinued. The whole circuit will now stay in this state indefinitely, until a negative pulse is applied to the base of Tr 2, switching it into the conductive state. The output voltage now rises to almost 0 volts (earth potential), driving the base of Tr 1 positive, and cutting it off. The output voltage at its collector now falls to the full negative potential, and this is applied to the base of Tr 2, holding it on, and via its output holding Tr 1 off.

The units are called NOR logic units because it is essential that neither trigger nor feedback inputs are live for a unit to have a live output. Earth potential, zero volts, is taken here as '0', no output, and for the PNP transistor shown in the circuit diagrams a negative potential is regarded as '1'. Therefore, if neither trigger nor feedback is logical '1' (ie, both are at 0 volts, logical '0'), then the transistor will have an output of the full negative potential (logical '1'). Conversely, if either of the inputs is live, logical '1', the output, will be dead, logical '0'. In the bistable circuit this logical '0' is fed into the second unit, which will then have a live output to feedback to the other input of the first unit. Outputs to operate further units or switching devices can be taken from either collector.

The astable circuit in *214a* operates in a similar manner to the bistable circuit, but the switching pulse is conveyed from the collector of one transistor to the base of the other via a capacitor. As soon as the second transistor has switched off, the capacitor charges from the negative supply line through the resistor located between it and the transistor, and when the voltage has become sufficiently negative the second transistor switches on again. The resulting rise in collector voltage is fed back to the base of the first transistor, cutting it off, and the second capacitor now charges through the other resistor. The time it takes to charge depends on its own value and the value of the resistor through which it charges. Once the circuit is switched on it alternates between the

two states continuously, and is self-starting because of the random electronic movements within the circuit at the instant of switching on. The monostable (flip-flop) circuit has one cross-coupling of each type, one resistive and one capacitive, with an external trigger to the stable side.

The cross-coupling resistors are frequently shunted by small capacitors (speed-up capacitors) to improve switching times for circuits working at high speeds, but they are not necessary for slow-speed switching.

(d) Transistor counting circuits

A counting circuit changes its state in regular sequence in response to a continuous series of pulses. The simplest form is a bistable circuit with the two inputs joined to a common pulse line via two steering diodes. The diodes are automatically forward or reverse biased by the connections to the transistors, so that the incoming pulse is routed to the 'on' transistor to switch it off, or to the 'off' transistor to switch it on, depending on the polarity of the pulse and other factors. Diagram 215 shows one such circuit. Alternatively, the diodes can be reverse biased from the collectors of the transistors via the resistors (216).

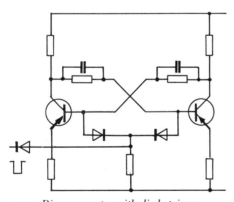

215 *Binary counter with diode trigger*

A ring counter is constructed of a series of units, only one of which can be conducting at any given time, and when a pulse is applied to the inputs, the unit switching off causes the next unit to switch on, the last unit switching on the first. The simplest ring counter is merely a

Opposite
216 Binary counter with diode trigger. Redrawn by permission of Mullard Limited from their Reference Manual of Transistor Circuits

Bistable circuit

Resistors	R1	1k Ω
	R2	4.7k Ω
	R3	6.8kΩ
	R4	6.8k Ω
	R5	4.7k Ω
	R6	1k Ω
	R7	10k Ω
	R8	10k Ω

Capacitors	C1	470 pF	} speed-up capacitors
	2	470 pF	
	3		} see below
	4		

Semi conductors D1 and 2 OA 81

TR1 and 2	t(μs)	C3 and C4 (pF)	Typical trigger prf
OC 71	10	4700	20 (kHz)
OC 200	2	1000	80
OC 41	1	470	200

t in μs = trigger pulse width
prf = pulse repetition frequency

series of NOR units, the bistable unit of *214b* extended to three or more transistors, with the output from each fed back to all the others to hold them off, and a more efficient routing network for switching on.

A more efficient ring counter uses thyristors. A simple thyristor d.c. switch *(217)* has two thyristors in parallel, with the anodes joined by a capacitor. When S.C.R. 1 is fired the capacitor charges through the resistor. As the anode potential of the thyristor is almost zero when conducting, when S.C.R. 2 is fired the capacitor discharges through S.C.R. 2 in a forward direction, and through S.C.R. 1 in the reverse direction, cutting it off. This circuit can easily be extended to cover any number of units to form a ring counter *(218a)*. Each unit is similar to the left hand half of the d.c. switch in diagram *217*, with the next load acting as the resistor through which the capacitor charges. The triggering network *(218b)* has a resistor R 1 through which the anode voltage (approx. zero volts) is applied to the cathode of the diode controlling the next stage, giving it a forward bias. The non-conducting thyristors will have an anode potential of approximately the

114

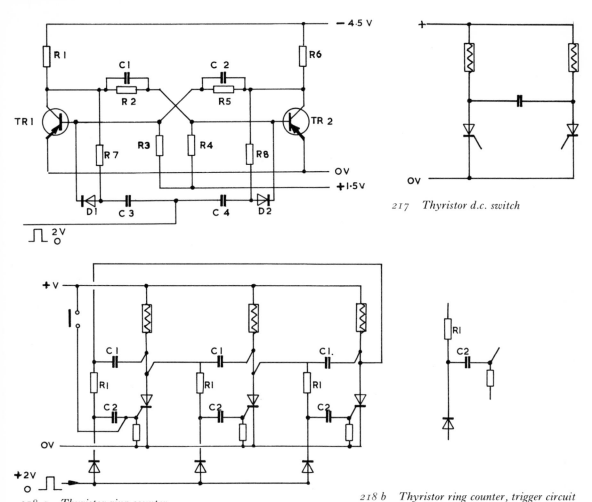

217 *Thyristor d.c. switch*

218 a *Thyristor ring counter*

218 b *Thyristor ring counter, trigger circuit*

positive supply, and will reverse bias their following diodes. When a positive trigger pulse is applied to the signal line only the forward biased diode will conduct and fire its associated thyristor through the isolating capacitor C 2. The capacitor between the conducting and subsequent stage now discharges, and turns off the conducting thyristor, the last stage being fed back to the first. A positive pulse has to be applied to the gate of the first thyristor of the ring to commence the sequence, and as each switching capacitor is held charged by the positive line, the interval between the firing of different stages is, for all practical purposes, limitless. The resistor across the gate of each thyristor prevents accidental firing by switching surges.

(e) Typical circuits

Diagrams *219 a, b* are of light sensitive switches. In (a) the light dependant resistor (l.d.r.) forms part of the voltage divider supplying the bias for the base of the transistor. When the illumination is at a high level, the resistance of the l.d.r. is low, and the base is biased positively, most of the voltage being dropped across the resistor forming the other half of the voltage divider network. When the level of illumination falls the resistance of the l.d.r. increases and the potential at the base of the transistor becomes sufficiently negative for it to conduct. This in turn causes the second transistor to conduct and the collector current flows through the relay and pulls it in. When the level of

115

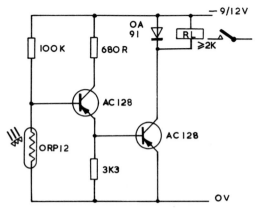

219 a (i) and (ii) Simple light sensitive switch

operating level can be altered by adding a variable resistor in the voltage divider.

A simple thyristor low voltage dimming unit and a mains voltage unit are given in diagrams *220 a, b*. The low voltage unit can have any number of channels up to the capacity of the 20 V load transformer winding. The 15-0-15 volt transformer winding is only for the control circuit and does not carry an appreciable load. The small unit with the fixed resistor and diode is for preloading the circuit so that the first circuit switched on is not affected by the second and subsequent circuits switched on.

illumination rises again the transistors cut off and the relay drops out. The surge of current due to the collapse of the magnetic field in the coil of the relay may cause damage to the second transistor, so the 'catching' diode is shunted across the relay to by-pass the surge round the relay. Diagram (b) shows a circuit in which the

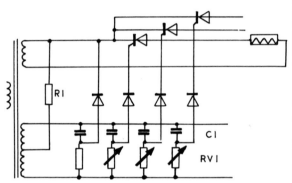

220 a Thyristor low-voltage dimming unit

Resistors R1 240Ω R2 100Ω *(pre loading)*
 RV1 5kΩ *wire wound*
Capacitors C1 2μF *(paper)*
Semiconductors
 Diodes OA81
 Thyristors *any 100V piv 16A*
Transformers
load circuit 20 volt, amperage to take full load
control 15–0–15 volt

The mains-voltage unit in diagram *220b* operates by shunting the output (d.c.) terminals of the bridge rectifier with the thyristor when it is triggered.

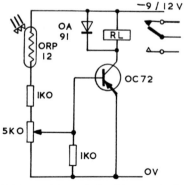

219 b Light sensitive switch with control of operating level

220 b Thyristor 240 V A C dimming unit. Redrawn by permission of Messrs S T C Semiconductors Limited, from their Application Note MF 146x

116

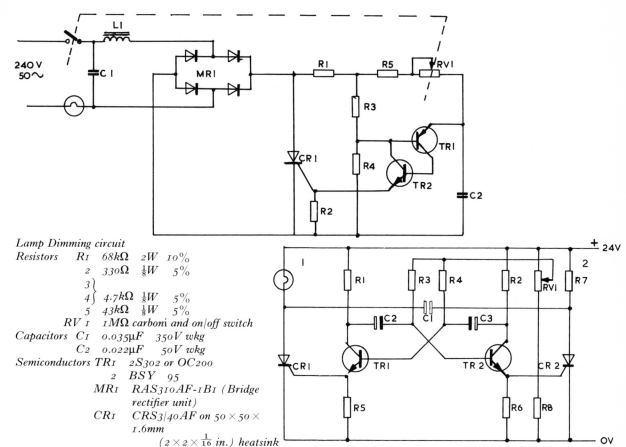

Lamp Dimming circuit
Resistors R_1 $68k\Omega$ $2W$ 10%
 2 330Ω $\frac{1}{8}W$ 5%
 $3\}$
 $4\}$ $4.7k\Omega$ $\frac{1}{8}W$ 5%
 5 $43k\Omega$ $\frac{1}{8}W$ 5%
 RV 1 $1M\Omega$ *carbon\i and on/off switch*
Capacitors C_1 $0.035\mu F$ $350V$ *wkg*
 C_2 $0.022\mu F$ $50V$ *wkg*
Semiconductors TR_1 $2S_{302}$ *or* OC_{200}
 2 BSY 95
 MR_1 $RAS_{310}AF$-$_1B_1$ *(Bridge*
 rectifier unit)
 CR_1 $CRS_3/_{40}AF$ *on* $50 \times 50 \times$
 1.6mm
 $(2 \times 2 \times \frac{1}{16}$ *in.) heatsink*

Inductor
Choke L_1 1.5 *mH* $3A$ *(In conjunction with capacitor* C_1 *forms a low-pass filter to prevent high-frequency transients generated by the circuit being transmitted back to the mains supply and causing radio interference to long and medium wave reception)*

A d.c. thyristor pulse unit can be made by combining the thyristor switch *(217)* and an astable multivibrator *(211)* into one circuit *(221)*. The loads 1 and 2 can both be lamps, or one lamp and one resistor.

A mains voltage flasher unit *(222)* combines the thyristor and bridge from diagram *220b*, and the multi-vibrator from diagram *211* with a zener diode to stabilise the input into the multivibrator and with voltage dropping resistors to reduce the input voltage. (See *chapter 12* for low voltage supplies and stabilisation).

221 *Thyristor D C flasher unit. Redrawn by permission of Messrs S T C Semiconductors Limited from their Application Note MF 218x*
DC Thyristor Beacon Flasher
Resistors $R_1\}$
 $2\}$ 820Ω $1W\}$
 $3\}$
 $4\}$ $22k\Omega$ $\frac{1}{4}W\}$
 $5\}$
 $6\}$ 150Ω $\frac{1}{2}W\}$ 5%
 7 240Ω $5W\}$
 8 $5.1k\Omega$ $\frac{1}{4}W\}$
 RV_1 $5k\Omega$ $\frac{1}{2}W$
Capacitors C_1 $16\mu F$ $50V$ *wkg* *reversible*$\}$ *electro-*
 $2\}$ $50\mu F$ $25V$ *wkg* *polarity* $\}$ *lytic*
 $3\}$
Semi conductors
 $TR_1\}$
 $2\}$ $BSY_{95}A$
 CR_1 $CRS_3/_{05}\,AF$ *on* $76 \times 76 \times 1.6$ *mm*
 $(3 \times 3 \times \frac{1}{16}$ *in.) aluminium heat sink*
 2 $CRS_1/_{05}\,AF$
Lamp load $100W$

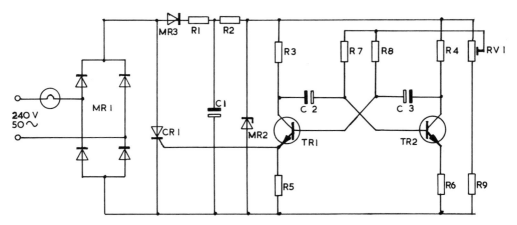

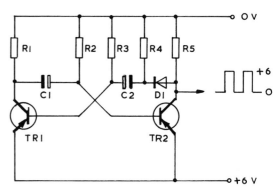

222　Thyristor 240 V A C. Redrawn by permission of Messrs S T C Semiconductors Limited, from their Application Note MF 145x

Resistors R1	1.5kΩ	10W	
2			
3	1kΩ	1W	
4			
5	150Ω	1W	5%
6			
7	22kΩ	$\frac{1}{2}W$	
8			
9	5kΩ	$\frac{1}{2}W$	
RV1	5kΩ	$\frac{1}{2}W$	
Capacitors C1	500μF	100V wkg	
2	50μF	25V wkg	electrolytic
3			

Semiconductors
CR1	CRS1/40AF	
MR1	RAS310AF–1B1	Bridge
MR2	Z3B200BF	rectifier
MR3	RS240AF	
TR1	BSY95	
TR2		

Diagram *223* shows a 1 Hz square wave oscillator which can be used as a trigger or a pulse circuit.

Diagrams *224* and *225* both show frequency-conscious circuits. The input in each case is from a tape recorder, record player, or any other low impedance (extension speaker) output from an amplifier, and both circuits control three separate groups of lamps.

In the circuit of diagram *224* the filter circuits are the inductors (coils) L 1, 2, 3 and their associated capacitors, and the power transistors Tr 1, 2, 3 drive the lamps directly. In the circuit of diagram *225* the filter circuits are the resistors

223　One Hz square wave oscillator. Redrawn by permission of Mullard Limited from their 'Dicta' leaflet

R1	4.7kΩ
2	47kΩ
3	47kΩ
4	2.7kΩ
5	4.7kΩ
C1	20μF Electrolytic 12V wkg
2	20μF

Semi conductors
TR 1	BCY72
2	
D1	BAX13

R 7, 8, 9 and capacitors C 5, 6, 7, 8. The output from these is fed into the resistor-capacitor networks which control the thyristors SCR 1, 2, 3 via transistors Tr 1, 2, 3.

Low frequency signals, eg, bass notes or a tone below 100 Hz from an audio frequency tone generator will cause one set of lamps to come on, and in the second circuit the volume of the tone will control the level of intensity.

118

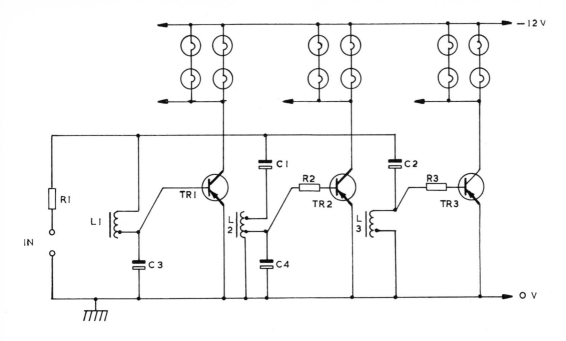

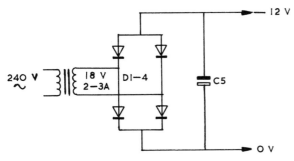

224 Frequency operated circuit. Redrawn by permission of the Editor of Practical Electronics

Resistors R1 *10Ω nominal (matching resistor)*

 2⎱ *10Ω ½W 10%*
 3⎰

Capacitors C1 *100µF*⎱
 2 *8µF*
 3 *50µF* *12V working*
 4 *12µF*
 5 *2000µF*⎰

Inductors L1 *Mullard LA 11 or Vinkor LA 2002*
 2 *pot core full winding tapped every 50*
 3 *to 60 turns 30 swg or primary of valve output transformer, capacitatively tuned.*

Semi conductors

 TR1⎱
 2⎬ *OC 35 (600 mA)*
 3⎰

 D1–4 *any 50V piv 3A diodes*

Lamps 6V *0.06A up to eighteen in series/parallel on each circuit*

 Frequencies *low 50–100Hz*
 middle 200 Hz–1kHz
 high 1–5kHz

The other two sets of lamps are controlled by tones of approximately 1 to 5 zHz (treble), and 100 Hz to 1 kHz respectively.

For fuller details of the methods of construction and operation refer to *Practical Electronics* August 1968 and August 1969 respectively.

119

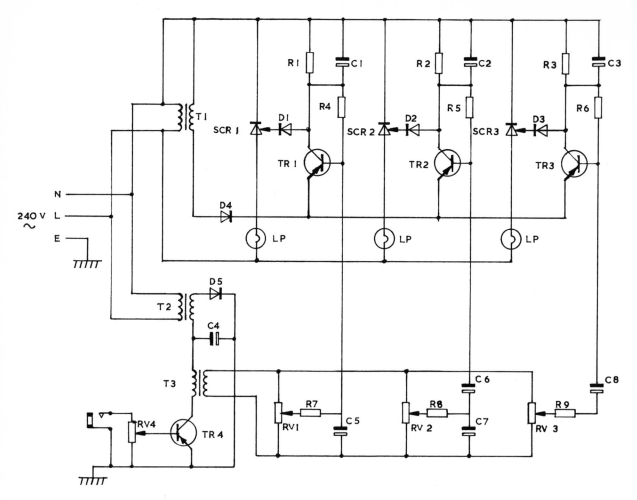

225 *Amplitude and frequency operated circuit (Chromatone). Redrawn by permission of the Editor of Practical Electronics*

Resistors
R_1
2 } 330Ω
3
4
5 } $56k\Omega$
6
7
8 } $1k\Omega$
9

Variable resistors
RV_1
2 } $10k$ log
3

4 25Ω *3W wire wound*

10%
½W

carbon

Capacitors
C_1
2 } $100\mu F$
3
4 $1000\mu F$ $15V$
5 $1.0\mu F$ *electro-*
6 $5.0\mu F$ *lytic*
7 $1.0\mu F$
8 $2.0\mu F$

Transformers
T_1 *mains primary*
2 *6.3V 1A secondary*
3 *valve output 3Ω*
 low impedence primary
 high impedance secondary

Semi conductors
D_1
2 } $OA91$
3
4 } $15V$ piv $1A$ (G.J. 7 m)
5 *silicon rectifier*

TR_1
2 } $OC 83$
3
4 $OC 26$

SCR_1
2 } $CRS3/40AF$, etc.
3 $400V$ piv $3A$

11 Electricity

Electricity is simply explained as the flow of electrons from atom to atom along the length of a wire. An atom is similar to the solar system, with a central nucleus surrounded by electrons in orbit, and when a potential difference is applied to a conductor the outermost electrons from the atoms at the beginning leave their orbits and pass on to the next atom, which then has too many electrons. This atom in turn releases the excess electrons to the next, and so on, thus creating a current *(226)*. Though the speed of electron drift is comparatively slow, the effect passed down the line from atom to atom travels with the speed of light, 300,000 km/sec.

226 Electron flow in a conductor

This electron flow behaves in many ways as the flow of water through pipes, and if an electrical circuit is thought of in terms of water it is much more easily understood.

(a) Units of measurement

The two measurements that can be made with regard to water are: (a) the pressure in a pipe, and (b) the quantity flowing through the pipe, measured in kilogrammes per square centimetre (pounds per square inch,) and litres (gallons) per minute respectively. The same two measurements applied to electricity are the electrical pressure or potential difference *(E)*, measured in volts *(V)*, and the quantity flowing or current *(I)*, measured in ampères or amps *(A)*. Just as pressure can exist in a pipe without any flow of water when a tap is turned off, so a potential difference or voltage can exist in a conductor without any current flowing when the switch is off (open). As soon

as the tap is turned on, the pressure will force the water to flow through the tap, and when the switch is closed the voltage will force a current to flow through the circuit.

The amount of work (in the engineering sense) that can be done by water is determined by the pressure and the quantity. One kilogramme (pound) (weight) of water falling from a height of ten metres (feet) will do as much work as ten kilogrammes (pounds) falling one metre (foot,) ie, ten kilogramme metres (foot pounds).

$$(\text{Pressure} \times \text{quantity} = \text{work},$$
$$10 \times 1 \text{ or } 1 \times 10 = 10).$$

The same kind of calculation obtains for electricity; the pressure *(E)* in volts \times the amount of current *(I)* in amps equals work done in watts *(W)* or power *(P)*. Therefore a current of 1 amp at 10 volts will produce the same wattage as a current of 10 amps at 1 volt.

$$E \text{ (volts)} \times I \text{ (amps)} = P \text{ (watts)}.$$

A car brake light bulb will draw a current of 2 amps at 12 volts to give 24 watts, but a 24 watt mains voltage bulb (240 volts) will consume only 0.1 of an amp.

$$12 \times 2 = 24, \quad 240 \times 0.1 = 24.$$

The easiest way to work out any of the three quantities, given the other two, is to put down the formula as a fraction *(227a)*, and cover up the required unit *(227 b, c, d)*.

227 a Diagram of the formula relating watts, volts and amps
227 b Formula for amps derived from (a)
227 c Formula for volts derived from (a)
227 d Formula for watts derived from (a)

A clean smooth pipe will allow the water to flow unhindered, but an old corroded pipe will resist the flow, slow the water down and reduce its pressure at the outlet. An electrical current will flow freely along a good conductor, but certain materials have the electrons more tightly bound into the atoms, and the current can flow only with difficulty. The current that flows through a resistance will always generate some heat, and the temperature of the resistance wire will rise. An electric fire and a tungsten fiament light bulb are simply resistances calculated to rise either to red heat and give out mainly heat, or to white heat and give out mainly light. The voltage (pressure) drives the current (quantity) through the resistance, and the greater the resistance the smaller the current. The voltage *(E)* therefore is the product of the current *(I)* × the resistance *(R)*.

E (volts) = *I* (amps) × *R* (ohms) Ω.

(The symbol for the unit of resistance is the Greek omega Ω). This again can be written as a fraction *(228a)*, and any unit found in terms of the other two by covering up the required unit *(228 b, c, d)*.

228 a *Diagram of the formula relating volts, amps and ohms*
228 b *Formula for ohms derived from (a)*
228 c *Formula for amps derived from (a)*
228 d *Formula for volts derived from (a)*

The 12 volt car brake light will have a resistance of $\frac{12}{2}$, which equals 6 ohms, the 240 volt mains bulb will have a resistance of $\frac{240}{0.1}$ equals 2,400 ohms.

The two formulae are often combined to eliminate the voltage and save one set of calculations.

$E = I \times R, \ P = E \times L,$
therefore $P = (I \times R) \times I$
$= I^2 \times R$

The calculations for the two bulbs would appear as follows:

$$\text{watts} = \text{amps} \times \text{ohms}$$
12 volt bulb $24 = (2)^2 \times 6$
$= 4 \times 6$
240 volt bulb $24 = (0.1)^2 \times 2,400$
$= 0.01 \times 2,400$

(b) Circuits

(See Appendix for list of symbols)

The simplest possible electrical circuit consists of a source (battery or generator), a load (heat, light or power), and two wires, one from the generator to the load, and a return wire from the load to the generator *(229)*. The direction of current flow was established long before atomic physics had determined the nature of an electric current, and conventional current is assumed to flow from the positive to the negative, though in fact the electrons flow *towards* the positive *from* the negative. A practical circuit would have, in addition, a switch (always in the positive lead, and as near to the source as practicable), and often a fuse link as well *(230)*.

229 *Simple circuit*

230 *Simple circuit with switch and fuse*

If the load consists of one lamp, the circuit is straightforward, all the current from the source goes through the lamp and returns to

the source. If there are two lamps they may be connected one after the other so that the electrons flow through both lamps in turn, a series circuit *(231a)*, or side by side so that the electron flow divides into two, and goes half through each of the two parallel paths, a parallel circuit *(231b)*. The calculations for the *total* load (between A and B in each case) are the same, but the current and voltage for each lamp in the two circuits are completely different.

231 a Simple series circuit

231 b Simple parallel circuit

(i) Series circuit

In a series circuit *(232)*, there is only one path for the electrons to take, and the flow must be the same in all parts of the circuit. If the circuit has two resistances each one will generate heat and consume power to do so. As the current must be the same through each, and power is current multiplied by voltage, some of the voltage must be 'dropped' across each of the resistances. If a potential difference of 12 volts

232 Voltages in a series circuit

is applied to a circuit with two resistors of 12 ohms each in series, the total resistance will be 24 ohms, and the current will be 0.5 amps.

$$12 = 24 \times \frac{1}{2}, \qquad V = O \times A$$

For each resistor
$$V = 12 \times \frac{1}{2}$$
$$= 6$$

So the voltage is dropped equally across both resistors, and 6 volts will appear across each.

(ii) Parallel circuit

A parallel circuit *(233)*, has at least two different paths for the electron flow, and the current from the source will be divided between the different branches of the circuit. As there is a direct path from the ends of each resistor to the source the same voltage will be applied to each resistor.

233 Amperages in a parallel circuit

If the 12 volts is applied to two 12 ohm resistors in parallel each resistor will draw 1 amp, so the total flow of current from the source will be 2 amps, half of which will flow through each resistor.

$$12 = 12 \times 1$$
$$V = O \times A \text{ for each resistor,}$$
$$\text{therefore for two resistors} \quad A = 2$$

and total
$$R = \frac{V}{A}$$
$$= \frac{12}{2} = 6 \text{ ohms.}$$

The full voltage is applied to each resistor and the current drawn from the source is shared between them.

(c) General application

A typical series circuit is the string of Christmas tree lights. A set for mains use having 20 lamps will have $\frac{240}{20} = 12$-volt lamps, and if each

123

lamp requires 0.5 amps, a total loading will still be 0.5 amps, as in series the same current runs through all the lamps, and the voltage is dropped in this case equally across all of them.

An example of parallel circuit is house wiring. Each lamp, heater etc. has its own pair of wires to the main distribution box, and has the full 240 volts applied to it. The total loading is the sum of the individual loads.

If a circuit is slightly overloaded the cables will begin to heat up and damage may result. In the case of a short circuit, in which the fault allows the current to take a shorter path than it should, by-pass the load and go directly to the return wire or to earth, the sudden surge of current can burn out a cable in a few seconds. A fuse (link) is designed to carry the full working load of the circuit that it protects, but under either of the overload conditions will melt and open the circuit to prevent further damage. A circuit-breaker performs the same function. The total load that is being taken from any point can easily be calculated by adding up the amperages of all the lamps, etc, being run from that point, and the total must *never* exceed the rating of the outlet. A fuse of a higher rating must never be used to replace one of a lower rating that is continually blowing. The only permissible remedy is to reduce the load.

The fuse link is always placed in the line or live lead (brown), and as near the outlet point as possible. The neutral (blue) lead is at the same potential as the earth (green and yellow), and if a fuse blows the whole circuit is instantly brought to earth potential and is safe. *234*, (a) correct, line fused; (b) incorrect, neutral fused. Before 1970 the line was red, neutral black, earth green in England. The equivalent colour code in the USA is line black, neutral white, earth green.

234 a Circuit with correct fusing

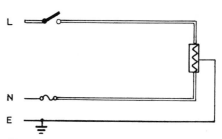

234 b Circuit with incorrect fusing (double line indicates part of circuit still live after fuse has blown)

For the same reason switches are always placed in the line before the apparatus so that the whole circuit is isolated when the switch is open (off).

Switches are classified by the number of separate circuits that are made or broken simultaneously. The simplest form is a single pole single throw (S P S T), or one-way switch *(235)*, the ordinary on/off switch. A double pole switch has two separate circuits in the same switch, both making and breaking together, and a double pole single throw (D P S T) can switch two electrically unconnected circuits simultaneously *(236)*.

235 Circuit with single pole single throw switch

236 Circuit with double pole single throw switch

A double throw switch or two-way connects one wire to either of two possible circuits, and may have a third position in the centre when both are disconnected (centre off). Double throw switches can be single pole (SPDT), or double pole (DPDT), *(237 a, b)*. Two two-way switches can be used to control one lamp from two points, eg, hall and landing switches controlling the stair light *(238 a, b)*. (a) is the correct way of wiring as less of the cable is live in any position. (b) used to be common, and is occasionally of use in low voltage wiring.

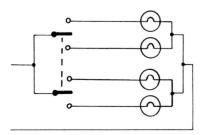

237 a *Circuit with single pole double throw switch*

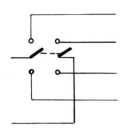

237 b *Circuit with double pole double throw switch*

238 a *Circuit with two-way switch, correct method of use*

238 b *Circuit with two-way switch, incorrect method of use*

An intermediate or change-over switch reverses the polarity of the output of wires relative to the input wires when operated. Placed between two two-way switches it makes a third control point for the circuits (239).

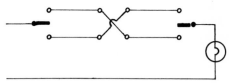

239 a *Circuit with intermediate or change-over switch*

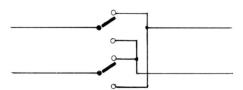

239 b *DPDT switch wired as a change-over switch*

12 Low voltage supplies and rectification

(a) Low voltage supplies

(i) Battery

The simplest source of a low-voltage supply is the dry-cell, or unit cell, which develops approximately 1.5 volts when new, dropping with use and age to about 0.9 volts, at which level it should be discarded. Any number of cells may be connected in series to give a higher voltage (eg, 3 cells in series for 4.5 volts). The chief disadvantage is the expense of renewal, as dry cells are quickly exhausted under a continuous load of any magnitude.

(ii) Mains transformer

A more efficient source is the mains transformer (240). It consists of two coils of wire placed in close proximity to each other, and linked by a common 'core' of iron. When a current is passed through the primary winding (a) it creates a magnetic field, which in turn induces a current to flow in the secondary winding (b).

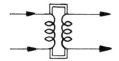

240 Transformer

As long as the primary current is rising and falling the current in the secondary will continue to follow it. In a transformer with equal windings the secondary (output) voltage will be theoretically the same as the primary (input) voltage. (There will be a slight loss due to heat being generated in both windings and the core.) If the secondary winding has half the number of turns in the coil as the primary winding the output voltage will be halved, and a secondary winding with twice the number of turns will give twice the voltage. The actual power transferred remains (theoretically) constant, so that a reduction in voltage will have a proportionate increase in amperage, and vice versa. This follows from the formula $P = V \times A$

eg, 24 watts $= 12 \times 2$ A
$= 24 \times 1$ A
$= 240 \times 0.1$ A

A car battery charger delivering 2 A at 12 V will draw only 0.1 A from the 240 V mains, and as currents in transistorised circuits are measured in milli-amps the cost of running a transformer is negligible.

Transformers are obtainable with several secondary windings to give different voltages simultaneously (241a), several tappings to give a choice of output voltages (b), or with a number of windings which may be connected in series or parallel to give either a wide choice of voltages (1 V to 80 V in one volt steps), or a fairly heavy current at one of two voltages (c). As there is no direct electrical connection between the primary and secondary windings in double wound transformers the output is effectively isolated from the mains supply. An auto-transformer has a single tapped winding, and provides no isolation. For reasons of safety its use is not recommended.

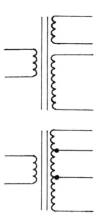

241 Transformers
(a) two secondary windings
(b) Tapped secondary winding

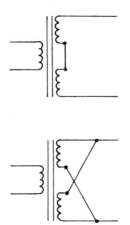

(c) (i) two secondaries, series connection
 (ii) two secondaries, parallel connection

(b) Rectification

An alternating current and a direct current, if used for heating, are interchangeable, as the passage of either through a resistance causes heat to be generated. This includes filament lamps as well as a heating element. For all other purposes the two forms of electrical power are completely different. It is a fairly simple matter to change one to the other, 'rectifying' a.c. to obtain a direct current, or 'inverting' d.c. to a.c. A d.c. voltage is changed to a higher or lower d.c. voltage by a 'converter', which is the d.c. equivalent of an a.c. transformer.

An a.c. current is considered to start from zero, rise to a maximum in a positive direction, fall to a maximum in a negative direction, and rise to zero again in one single cycle (242). If the current is imagined to flow forwards along the conductor at a gradually reducing speed until

242 Graph of alternating current

it reverses and flows backwards, and reverses again and flows forwards, this gives a more accurate impression of what actually happens. If a simple check valve were inserted in a water pipe in which the water was flowing in this manner, the reverse flow would be stopped, and only the forward flow would be passed by the valve (243). In a similar way an electric current can be controlled by a rectifier which will pass the pulses in one direction, but block the pulses in the reverse direction. There are several ways of doing this, but only semiconductor diode rectification will be considered here. The thyristor or silicon controlled rectifier is discussed in chapter 9, section (d). The simplest rectifier is the half-wave rectifier, which has a single diode in one side of the output from the transformer (244). This cuts off half of the pulses, so that the d.c. output voltage will be in the region of 0.45 of the a.c. output voltage from the transformer. The d.c. will be pulsating, but the pulses are reduced by smoothing circuits (section (c)), or voltage stabilisers (section (d)).

243 Diagram of hydraulic valve

244 Half-wave rectification

A more efficient circuit is the full-wave rectifier (245), which has two diodes, one at each end of the secondary winding, but it needs a centre-tapped transformer. The full a.c. output voltage appears across each end of the secondary winding alternately, between the end of the winding and the centre tap. The pulsating d.c. is at twice the frequency of the a.c. as both

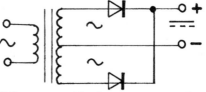

245 Full-wave rectification, centre tapped transformer

the positive and negative pulses are applied in turn to the output. The d.c. voltage is approximately 0.9 of the a.c. voltage.

The full-wave bridge circuit *(246)*, has a similar efficiency, the average d.c. voltage being taken as 0.9 of the a.c. voltage, and it does not need a centre-tapped transformer. As two diodes in series are conducting at all times the diodes can be smaller, and of course the transformer secondary is only half the size of that required for the centre-tapped full wave circuit. When the upper end of the transformer secondary is positive, the current flows out through D 1 and back through D 3. When the lower end is positive it flows through D 2 and D 4.

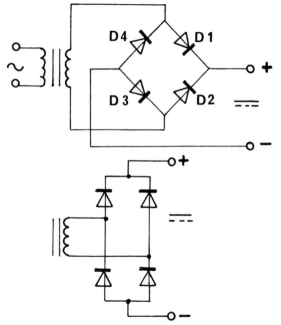

246 *Full-wave rectification, bridge rectifier*

In all rectifiers the diodes must be able to withstand a considerable reverse voltage, known as the peak inverse voltage (p.i.v.), as well as a greater forward current than the working current. Diodes are rated by forward current and p.i.v. If a reservoir capacitor is used for smoothing the output (see section (c)), peak inverse rating (p.i.r.), should be at least twice the forward voltage, and the peak current rating may need to be as much as three times higher than the average forward current.

(c) Smoothing circuits

The simplest way of smoothing is to connect a large value capacitor in parallel with the load across the output *(247)*. This charges on the positive pulses, and discharges through the load on the negative pulses. It must be large enough to store sufficient energy to maintain a voltage comparable to the output from the transformer, but not too large for the diode to be able to charge in addition to supplying the load.

247 *Svoothing by capacitor*

A more efficient smoothing circuit uses a choke or coil which offers an impendance to any change of current, followed by a capacitor which blocks a steady current but passes a fluctuating current *(248)*. The choke passes the d.c. component of the output current, but impedes the a.c. component or ripple, and the capacitor C short-circuits the a.c. component, but is an open-circuit to the d.c. component. This low frequency filter circuit can be preceded by a capacitor, which will increase the d.c. output, though the voltage will drop appreciably as the load increases *(249)*.

248 *Smoothing by choke input filter*

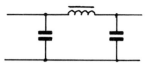

249 *Smoothing by capacitor input filter*

If the choke is replaced by a resistor there is a greater voltage drop and power loss, but the filter is much less expensive *(250)*.

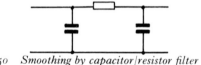

250 *Smoothing by capacitor/resistor filter*

(d) Voltage stabilization

A simple transistor series stabilizer is shown in diagram *251*. The zener diode (Z) has the property of breaking down and conducting in reverse at a definite voltage. Below this voltage (the zener voltage) the diode is non-conducting, above this voltage the diode conducts heavily in reverse. Thus the point (a), for practical purposes, can never exceed the breakdown voltage under normal load conditions. Assuming, for simplicity, that the load and R are of equal resistance, and ignoring the transistor *(252)*; as the voltage rises the voltage at (a) will rise, remaining midway between the total voltage and zero in value. As long as the voltage drop across the load is less than the zener value, the zener diode will not conduct, but as soon as this value is exceeded across the load the zener diode will conduct, thus reducing the combined resistance of the load and diode network. This means that a larger proportion of the voltage will be dropped across R, and the voltage at (a) will remain at approximately the

in input (negative feedback), the voltage will be kept much more stable. Protection of the power transistor is obtained by the addition of a current limiting or overload protection circuit, which drops the voltage nearly to zero when the current exceeds a predetermined value. *254* shows a typical voltage stabilizer, including a series resistor (R 1) to limit the output current, a minimum load resistor R 3, and input and output filter capacitors C 1 and C 2 to smooth the d.c. ripple.

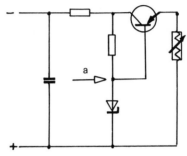

253 Series stabiliser

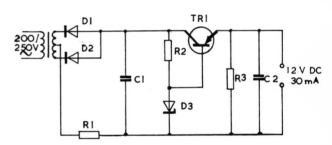

254 Voltage stabiliser. Redrawn by permission of Radiospares from their Component Applications Data 1969

Resistors R1	120Ω	
R2	3.3kΩ	
R3	5.6kΩ	
Capacitors C1	100μF	
C2	50μF	
Semi conductors		
TR1	OC84 or 2G382	
D1	1 SJ 150	
D2		Radiospares
D3	M–ZE 12v	

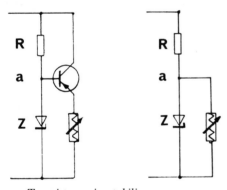

251 Transistor series stabiliser
252 Zener diode stabilising

zener voltage. In diagram *251* the base emitter voltage of the transistor is held constant, so that the collector-emitter output voltage is held reasonably constant. The circuit is usually drawn as in *253* to conform with the convention that the input and output are at the extreme left and right of the circuit.

This basic circuit does not provide full stabilization, the output varying slightly with variation in load and temperature. By feeding part of the output back to the input in such a way that an increase of output causes a decrease

129

Appendices

1 SI Units and abbreviations

The International System of Units (abbreviated to S.I., Système International) is gradually superseding the old metric system of which it is an extension.

There are six basic units, and all other units are compounds of these. The four units which occur most frequently are the metre, kilogramme, second and ampere, and these have been used for a number of years in scientific work as the M.K.S. or M.K.S.A. systems. The prefixes are as given below, and no others should be used. Decimetre and centimetre in particular are used only when expressing area and volume, and not for length (capacity is expressed in litres and millilitres).

The number preceding a unit should be in the range 0.1 to 1,000, eg 746 mm or 0.746 m; 20 mA, not 0.02 A; 300 megametres not 300,000 km. Spaces, full stops and hyphens are avoided, eg kV kilovolt, ms millisecond, and 'per' is replaced by the solidus '/' in expressions such as m/s, metres per second.

When writing numerals with more than three digits spaces are left between groups of three digits, and commas are not used, thus preventing confusion with the decimal point.

Some of the common electrical units are as follows.

Electrical or magnetic quantity	Quantity symbol	Unit	Unit symbol
Current	I	Ampère	A
Voltage	V	Volt	V
Electromotive force	emf	Volt	V
Potential difference	E	Volt	V
Resistance	R	Ohm	Ω
Reactance	X	Ohm	Ω
Impedance	Z	Ohm	Ω
Power	P	Watt	W
Apparent power	S	Voltamp	VA
Inductance	L	Henry	H
Capacitance	C	Farad	F

In some instances the electrical unit has a value much too high or too low for electronic purposes, and a submultiple or multiple of the unit is used. This does not mean that the electronic values are extreme; an approximate example would be to quote weights in thousandths of a ton instead of pounds, or in thousands of ounces instead of hundredweights.

The table below gives the prefixes used to denote multiples and submultiples of the basic units, their abbreviations and values.

Prefix	Abbreviation	Multiplying factor	
tera	T	1 000 000 000 000	$=10^{12}$
giga	G	1000 000 000	$=10^{9}$
mega	M	1 000 000	$=10^{6}$
kilo	k	1 000	$=10^{3}$
milli	m	0.001	$=10^{-3}$
micro	µ	0.000 001	$=10^{-6}$
nano	n	0.000 000 001	$=10^{-9}$
pico	p	0·000 000 000 001	$=10^{-12}$
femto	f	0·000 000 000 000 001	$=10^{-15}$
atto	a	0·000 000 000 000 000 001	$=10^{-18}$

Units of length,	Kilometre	Km	1 000m	10^{3}
	metre	m	1m	10^{0}
	millimetre	mm	0.001m	10^{-3}
	micron		0.000 001m	10^{-6}
	millimicron		0·000 000 001m	10^{-9}
	A	Angstrom unit		

$=10^{-8}$cm (10^{-10}m)
(light wavelength)

Other abbreviations are:

Hz	Hertz	Frequency (replaces cycles per second)
p.i.v.	peak inverse voltage	Indicates the maximum reverse voltage that a semiconductor device will withstand
p.i.v.	peak inverse rating	
r.m.s.	root-mean-square	The 'working' voltage or amperage of an alternating current as distinct from the 'peak to peak' value

The British Standards Institution recommends the following use of type:
Physical quantities in *italic*, eg *V* voltage
Symbols for units in Roman, eg V volts

Subscript abbreviations in lower case for quantities varying with time; capitals for steady or d.c. values

No full points are used in abbreviations unless initials are used, eg a.c. (alternating current).

2 Pulfrichs pendulum

This is a very convincing demonstration of the slowing down of the rate of firing of the receptors when the eye is dark-adapted. A pendulum 1.5 to 2 metres (four or five feet) long is viewed from a position at right angles to the direction of its swing, with one eye partially dark-adapted by covering it with a dark filter or one lens of a pair of sun glasses. The slower rate of firing causes the dark adapted eye to see the pendulum in the position that it was a fraction of a second earlier, unlike the unadapted eye, which sees it virtually instantaneously. The discrepancy between the two perceived positions creates the effect of an apparently greater or lesser distance between the observer and the pendulum, caused by binocular depth perception, and varying with the rate and direction of the swing of the pendulum relative to the eye of the observer, (diagram 255). When the pendulum is at position A, and swinging to the right, the dark

adapted (left) eye sees it at A_1 and therefore the pendulum is perceived apparently at A_2. When the pendulum is swinging to the left at B, it is seen at B_1 by the dark-adapted eye, and is perceived at B_2. The pendulum therefore appears to swing in an ellipse across the line of vision instead of in a straight line.

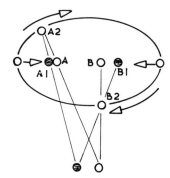

255 Pulfrichs pendulum

3 Rhombic dodecahedron

This is a facially-regular solid with twelve rhombic faces whose angles correspond to the Maraldi angles of 70° 32′ and 109° 28′. The net for its construction is drawn out in diagram 256. Tabs for assembly should be left on alternate sides throughout, and all lines should be scored lightly on the face. Rhomba of 35 mm (1½″) side will make a solid approximately 150 mm (6″) in diameter.

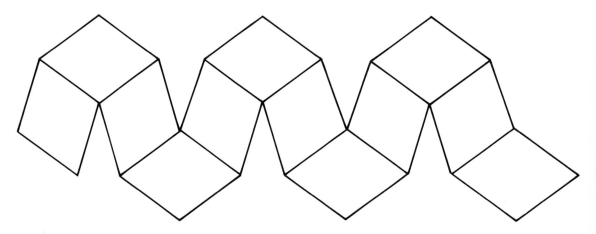

256 Development of the rhombic dodecahedron

132

4 Details of construction

(a) Shutters and frames

The shutters in the photographs were all cut from 3 mm plywood, and the frames and slides were built up from 3 mm ($\frac{1}{8}''$) or 5 mm ($\frac{3}{16}''$) strip glued and pinned together, thus obviating the necessity for any other than the simplest of woodworking techniques and tools (diagram 257). To prevent the wood splitting when the pins are driven in it should be held in a cramp or a vice, and the end of the pin blunted slightly by a sharp tap with the hammer so that the pin tends to punch a hole through the wood fibres rather than force them apart and split them.

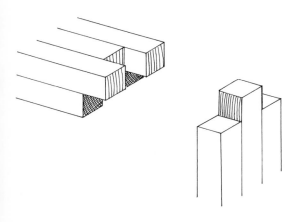

257 *Methods of jointing laminated frames*

(b) Rotors

The simplest method of fixing a rotor to a spindle is to use studding, (a metal rod which has a screw thread cut along its whole length), and lock nuts. A nut and washer are placed on each side of the rotor and then tightened up (in opposite directions) until the rotor is locked between them. The main drawback to using studding is that the thread causes it to creep along the bearings and creates excessive friction at one end or the other of the rod. This disadvantage can be overcome by using plain rod and cutting a thread on it at each end only, with a die. This operation is not difficult provided that the ends of the rod are filed square before beginning to cut the thread, the die is kept always at right angles to the axis of the rod, and that it is never forced forward, but is given only about one third of a turn and then backed slightly to clear the swarf from the die. A small metal-working vice which clamps to the bench top is quite adequate to thread up to 7.5 mm ($\frac{5}{16}''$) mild steel or silver steel rod.

A simple way of attaching a rotor to a synchronous clock motor is to put a small round headed bolt 3.5 mm or 3 mm (4 or 6 BA) through the centre, and hold it in place with a nut and lock-washer, and then put it into one section of an electrical wire connector known as 'barrier strip', tightening the screws, which would normally hold together the two wires to be joined, on to the bolt in the rotor and the spindle of the motor respectively. 15 amp barrier strip has a hole large enough to take up to 4.5 mm (2 BA) bolts; 5 amp and 2 amp are smaller and neater.

5 Electronic and electrical symbols and resistor code

Diagram *258* shows several semiconductor devices, and *(259)* gives the circuit symbol and outline drawings with the connections or polarities marked. The diode D is connected so that the marked end (cathode) acts as the positive terminal of the power source, and the current leaves by the cathode. The low power transistors (A & J) and the power transistor (C) all have the same symbol. The outline drawings give the terminals of the devices in the illustration. The thyristor or S.C.R. (K) may be represented by two different symbols, either of which can show an anode or cathode gate.

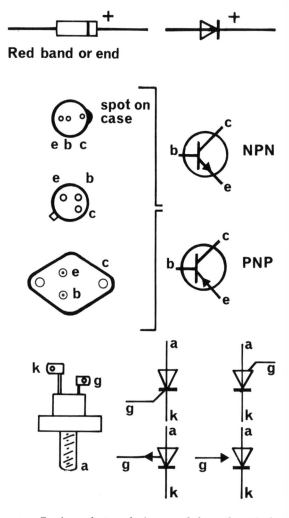

Red band or end

259 Semi conductor devices symbols and typical outline drawings. (Transistor cases and lead positions vary considerably)

258 Semi conductor devices and photographs. Reproduced by courtesy of Mullard Limited from their Minibook No. 3

Resistors (R) *(260)* also have two alternative symbols *(261)*, (a) is the new BSI recommendation in accordance with international agreement, and (b) is the former symbol it replaces. (c) appears frequently in continental books, and is recommended by BSI for non-reactive resistors.

134

260 Resistors, fixed (R) carbon

a

261 Resistor symbols
(a) recommended
(b) not recommended
(c) non-reactive resistor

Variable resistors (262) may be either pre-set
(a (i) and (ii)) or variable as required (b). A
pre-set component (resistor or capacitor) is
set with a screwdriver or slider to trim a circuit,
and once set is normally not altered again. A
variable component is controlled manually by
a knob on the control panel, and is used to tune
a circuit or control the level of output. The
pre-set symbol is a diagonal line with a cross
bar at the end drawn over the symbol for the
component, and the variable symbol is a
diagonal arrow.

262 Resistors variable (RV)
262 a (i) and (ii) Preset vertical
and horizontal

262 b variable

Figure 263 (a) is the symbol for a pre-set
resistor, and (b) is that for a variable resistor.
c i and ii are pre-set and variable potential
dividers (pots). The same component is used
for both purposes. As a variable resistor two
terminals are used, input and the variable
output. As a potential divider three terminals
are used, and the central wiper picks off any
voltage between zero and the full voltage, the
balance being directed elsewhere in the circuit.

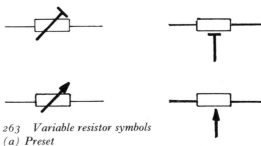

263 Variable resistor symbols
(a) Preset
(b) variable
(c) (i) and (ii) preset and variable potential dividers

Capacitors (C), (diagram 264 a, ceramic disc,
b, polyester, c, electrolytic) are represented by
the two parallel plates of a single capacitor.

264 Capacitors (C)
(a) ceramic disc

135

(b) polyester

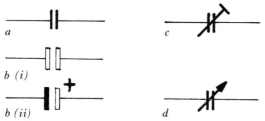

(c) electrolytic

(265 a) is a non-electrolytic capacitor, b (i) is a non-polarised electrolytic and b(ii) is a polarised electrolytic capacitor. Pre-set (c) and variable (d) capacitors have the usual symbols superimposed on the capacitor symbol.

265 Capacitor symbols
(a) non electrolytic
(b) (i) non polarised electrolytic
 (ii) polarised electrolytic

Inductors or coils (L) are represented by a conventionalised coil winding *(266 (a))*. The version in (b) is no longer recommended. Cores are shown as in transformers, and tuned coils with the pre-set or variable symbols.

266 Inductor symbols (L)
(a) recommended symbol
(b) non recommended symbol

Transformers are represented by two windings back to back *(267)*, and cores by the absence (air core) or presence of continuous lines (laminated core) or dashed lines (dust core) (b and c). (See also *chapter 12*, diagram *241*). Chokes or ballasts are shown as coils *(268 a)* and iron-cored chokes (b) with a solid line alongside the coil (as in the iron-cored transformer).

(a) air core (b) laminated core (c) dust core
267 Transformers

(a) no core (b) iron core
268 Choke or ballast

Filament lamps are indicated as in *(269 a)*, and signal lamps as in (b).

(a) filament (b) signal
269 Lamps

Connecting wires in a circuit diagram are shown as solid lines *(270)*. All permanent joints are indicated by a black spot on the junction. No more than three wires should connect with any one point (a). When four wires join, the actual junction should be staggered or offset (b). Where two wires cross (always at right angles) the wires are drawn

136

without the dot (c). The non-preferred alternatives of breaking one wire or of bridging are also shown. Any permanent (soldered) connection is shown as a solid circle and any temporary connections (switch terminal or input or output terminals) are shown as rings (d).

270 *Wiring (a) join*

(c) crossing wires

(b) staggered junction

(d) connections

Table of resistor codes (British and RMA-JAN (USA)

Resistors have a series of coloured bands round the body at one end of the component. The first band is the first digit of the value, the second band is the second digit, the third band is the number of zeros to be placed after the first two digits (the multiplier), and the fourth band if present indicates the tolerance above or below the stated nominal value.

Colour	Digits	Multiplier		Tolerance
Black	0	1	10^0	
Brown	1	10	10^1	
Red	2	100	10^2	
Orange	3	1 000	10^3	
Yellow	4	10 000	10^4	
Green	5	100 000	10^5	
Blue	6	1 000 000	10^6	
Violet	7	10 000 000	10^7	
Grey	8	100 000 000	10^8	
White	9	1 000 000 000	10^9	
Gold	$\div 10$	10^{-1}		5%
Silver	$\div 100$	$\div 10^{-2}$		10%
No colour				20%

137

BS 1852 Resistance code

BS 1852 Resistance code
Resistors in the order of ohms are denoted by R

kilohms	K
megohms	M

digits before the letter are before the decimal point, and after the letter are behind the decimal point. Tolerance is indicated by a further letter.

F	10 per cent
G	2 per cent
J	5 per cent
K	10 per cent
M	20 per cent

eg, 5 ohms 10% resistor is 5R0K

 5.6 kilohms 20% resistor is 5K6M

 10 megohms 5% resistor is 10MJ

To keep the range of resistor values down, preferred values are used. The 10 per cent preferred values between 1 and 10 are as follows:

1.0

1.2

1.5 Between them they cover the entire

1.8 range from 1 to 10 ohms, as the upper

2.2 limit of one value is the same as the

2.7 lower limit of the next higher value.

3.3 The next two decades are of course

3.9 the same range multiplied by 10 or

4.7 100. The third decade uses a metric

5.6 prefix and the units range again. eg,

6.8 1 ohm, 10 ohms, 100 ohms, 1 kilohm,

8.2 10 kilohms, etc.

Bibliography

The range of books available on the various topics discussed in this book is so vast that no more than a representative selection is given here. The electronics section includes some books suitable for a comparative beginner as well as more specialised books.

Vision and perception

Eye and Brain, R. L. Gregory, Weidenfeld and Nicolson, World University Library, London, and McGraw-Hill Book Company, New York 1966

Seeing and Perceiving, C. W. Wilman, The Commonwealth and International Library and Pergamon Publishing Co Limited, Elmsford, New York

The Psychology of Perception, M. D. Vernon, Pelican Publishing Co. Inc, New Orleans 1962

The Intelligent Eye, R. L. Gregory, Weidenfeld and Nicolson, World University Library, London, and McGraw-Hill Book Company, New York 1969

Optical Illusions and the Visual Arts by R. G. Carraher and J. Thurston, Van Nostrand Reinhold and Studio Vista, London

The Graphic Works of M. C. Escher, Macdonald, London 1969 and Hawthorn Books, New York

Kinetic art

L'Art Cinetique, F. Popper, New York Graphic Society Limited, Greenwich, Connecticut 1969

Light

Colour and Colour Measurement in the Graphic Industries, V. Letouzey, Pitman, London 1957

Curiosities of Light Rays and Waves, S. Tolansky, Veneda Publishing Co and American Elsevier Publishing Co Inc, New York 1965

Light, C. B. Daish, English University Press, London 1954

Nature of Light and Colour in the Open Air, M. Minnaert, Bell and Dover Publications Inc, New York 1948

Electronics

Basic Principles of Electronics and Telecommunications, M. D. Armitage, Harrap, London, and Lawrence Verry Inc, Mystic, Connecticut 1966

Computer Models, A. Wilkinson, Edward Arnold 1968

Electronic Counting, Mullard Limited, London

Electronics Pocket Book, V. P. Hawker and J. A. Reddihough, Newnes, London 1967

Everyday Electronics, T. Roddam, Harrap, London, and Lawrence Verry Inc, Mystic, Connecticut 1966

Introduction to Counting Techniques and Transistor Circuit Logic, K. J. Dean, Chapman and Hall, London 1964, US distributor Barnes and Noble, Inc, New York

Reference Manual of Transistor Circuits, Mullard Limited

Semiconductor Circuits, J. R. Abraham and G. J. Pridham, Commonwealth Library

The Transistor : Basic Theory and Application, J. Dosse, D. Van Nostrand, London 1965 and Van Nostrand-Reinhold, New York 1964

Transistor Circuits, K. W. Cattermole, Hewwood-Temple 1964

Thyristors and their Applications, A. W. J. Griffin and R. S. Ramshaw, Chapman and Hall, London 1965

We Built Our Own Computers, A. B. Bolt, Cambridge University Press, London 1966

Practical Electronics monthly magazine

Manufacturers, technical publications and/or applications notes
Mullard Limited, Mullard House, Torrington Place, London WC 1
International Rectifier, Hurst Green, Oxted, Surrey
S.T.C. Semiconductors Limited, Footscray, Sidcup, Kent

Bibliography USA

Compiled by R. G. Costello PhD
The Cooper Union for the Advancement of Science and Art

Optics—general texts

Principles of Optics, M. Born and E. Wolf, second edition, The MacMillan Company Inc, New York 1964

Fundamentals of Optics, F. A. Jenkins and H. E. White, third edition, McGraw-Hill Book Co Inc, New York 1956

Optics, F. W. Sears, Addison-Wesley Inc, Cambridge, Massachusetts

Optics—interference and moiré patterns

Moiré Patterns, G. Oster and Y. Nishijima, Scientific American 1963 (reprints available from W. H. Freeman, Publishers, San Francisco)

The Interference Systems of Crossed Diffraction Gratings, J. Guild, Oxford University Press 1956

The Science of Moiré Patterns, No. 9068, G. Oster. An easily understood, heavily illustrated text, available from Edmund Scientific Co 1969

Electronics—theory and analysis—introductory college level

Electrical and Electronic Engineering Fundamentals, A. Fitzgerald and D. Higginbotham, McGraw-Hill Book Co, New York 1964

Transistor Circuit Engineering, R. F. Shea, John Wiley and Sons, New York 1957

Electronics for Scientists and Engineers, R. Benedict, Prentice-Hall Inc, Englewood Cliffs, New Jersey 1967

Electronics—practical circuit design

Transistor Manual, General Electric Co, Syracuse, New York. Published annually, available in local electronics supply houses or via the mail from the listed electronics suppliers. This handbook contains hundreds of circuits, as well as an introduction to transistor theory, and a list of transistor types and specifications

Transistor Manual, R.C.A., Harrison, New Jersey. Similar to the above, but less detailed

SCR Manual, General Electric Co, Auburn, New York. Similar to above, but concerns silicon control rectifiers, used in light organs, light dimmers, and motor speed controllers.

Suppliers in Great Britain

Electronic kits

Heathkit, Daystrom Limited, Gloucester

Test instruments of all kinds, and basic instruction kits which include excellent tuition manuals and kits for building various instruments.

Retail suppliers

Small components can usually be purchased locally from radio shops, and the names and addresses of mail-order firms can be found in the advertisement sections of *Practical Electronics* and *Wireless World*.

Wholesale suppliers (trade, colleges, schools)

A. C. Farnell, Kirkstall Road, Leeds 3

Radiospares, PO Box 427, 13–17 Epworth Street, London EC 2

S.T.C. Semiconductors Limited, Footscray, Sidcup, Kent

Suppliers in USA

Compiled by R. G. Costello PhD
The Cooper Union for the Advancement of
Science and Art

Entire supply spectrum

Edmund Scientific Company
402 Edscorp Building
Barrington, New Jersey 08007
*By far the best single source for lenses, lamps,
motors, diffraction gratings, ronchi rulings,
color filters, color wheels, and just about every
possible item mentioned in the text*

Electrical and electronic equipment

Lafayette Radio Electronics
111 Jericho Turnpike
Syosset, Long Island, New York 11791

Allied Radio
100 N. Western Avenue
Chicago, Illinois 60680
*Excellent sources for electronic equipment, lamps,
switches, relays, tools, cables, connectors, trans-
formers, and some optical equipment*

Industrial electronics catalog

Newark Electronics Corporation
500 N. Pulaski Road
Chicago, Illinois 60624

Optical equipment—commercial quality

Oriel Optics Corporation
1 Market Street
Stamford, Connecticut 06902
*A supplier of very high quality optical mounts,
filters, light sources, lenses and precision optical
components*

Optics Technology Inc
901 California Avenue
Palo Alto, California 94304
Lasers and laser equipment

EG & G Incorporated
160 Brookline Avenue
Boston, Massachusetts 02215
High power strobe lamps and supplies

Bausch & Lomb Inc
Rochester, New York 14602
Very high quality optical equipment

Plastic suppliers

Mail Order Plastics
58 Lispenord Street
New York, NY 10013

Industrial Plastic Supply Company
309 Canal Street
New York, NY 10013
*Plastic sheet, rods, domes, boxes and other
shapes in both clear and colored form*

Lamps and light sources
General Electric
219 E. 42 Street
New York, NY 10017

Electronic kits

Heathkit Electronic Center
35 W. 45th Street
New York, NY

Pertinent catalogs are :
Index of all Lamps	3—6255
Sealed Beam Lamps	3—6251
Sub Miniature Lamps	3—6252
Miniature Lamps	3—6253
Glow Lamps	2—6254

Index

Numerals in *italics* refer to illustration numbers